Vintage Floral Fantasy

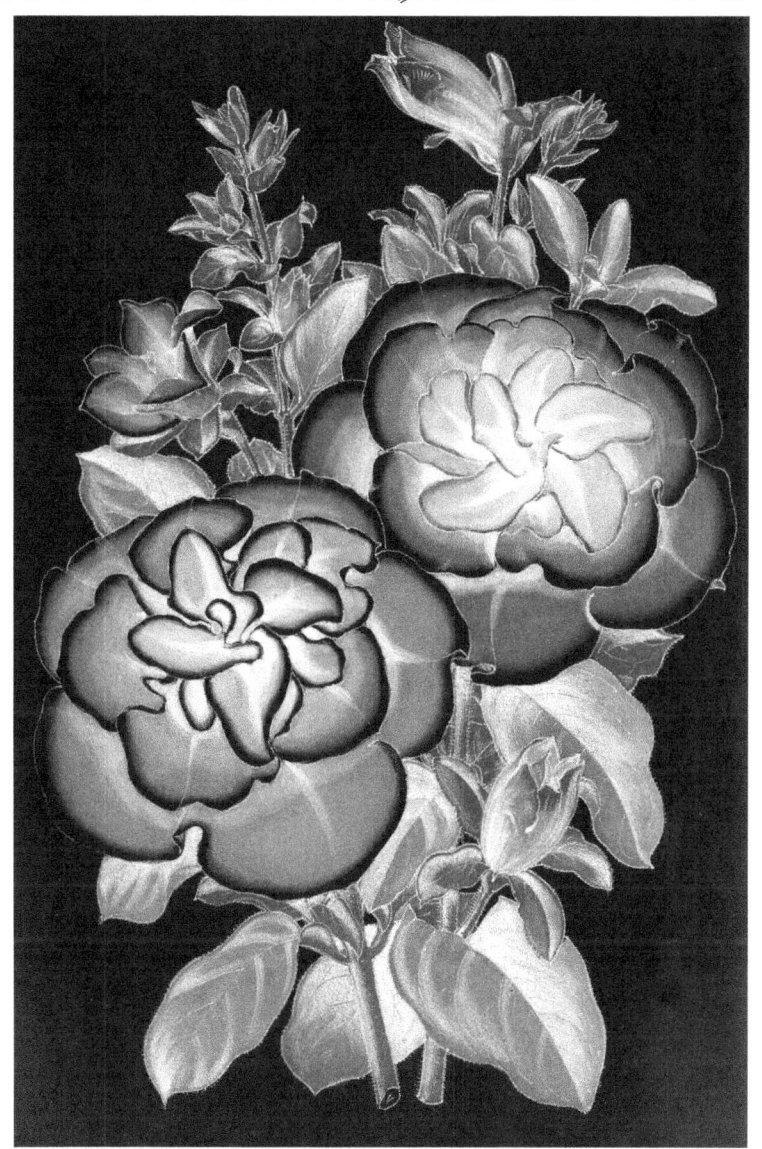

Grayscale Adult Coloring Book

Olde Glorie Studios

Copyright 2016
Olde Glorie Studios
All Rights Reserved

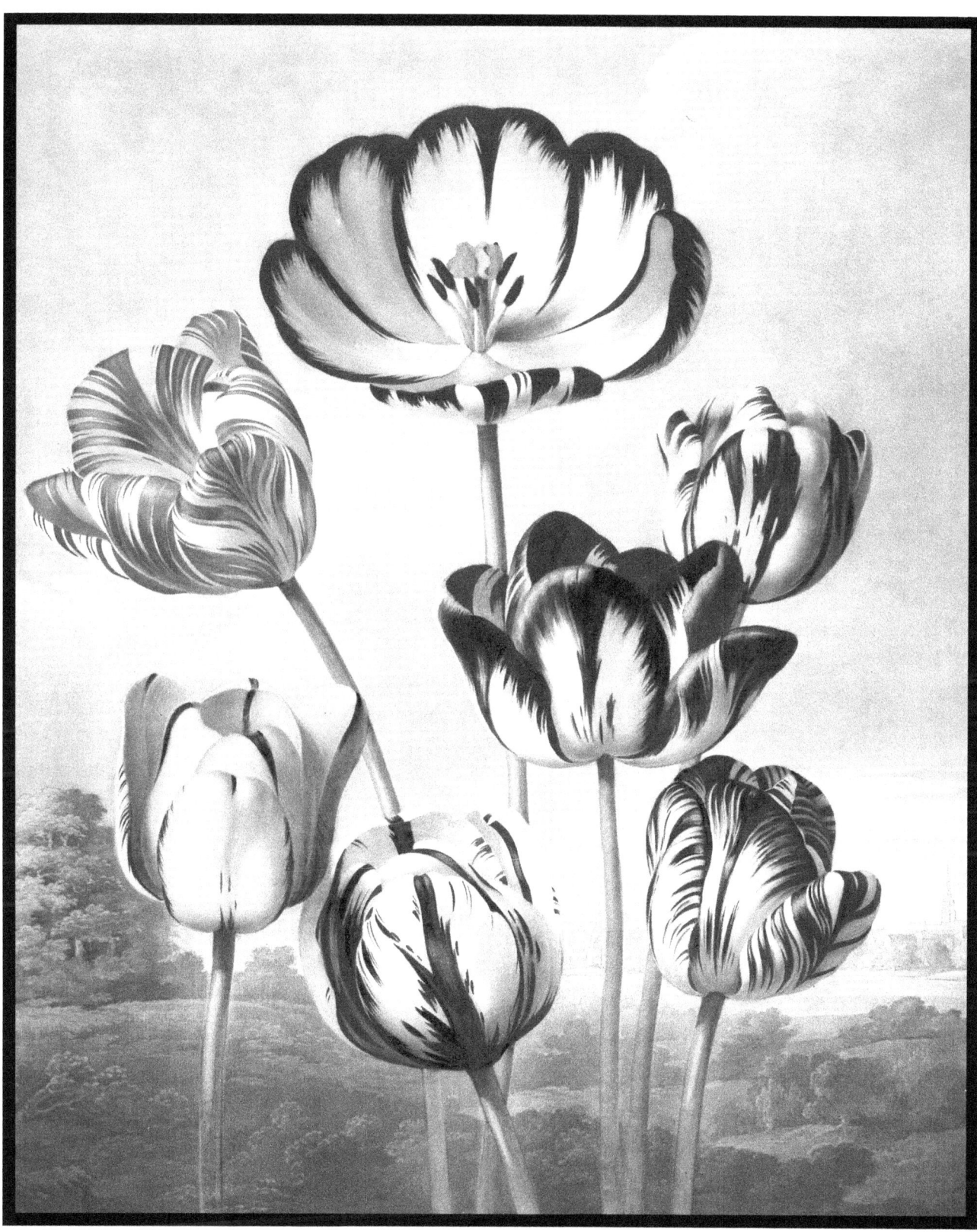

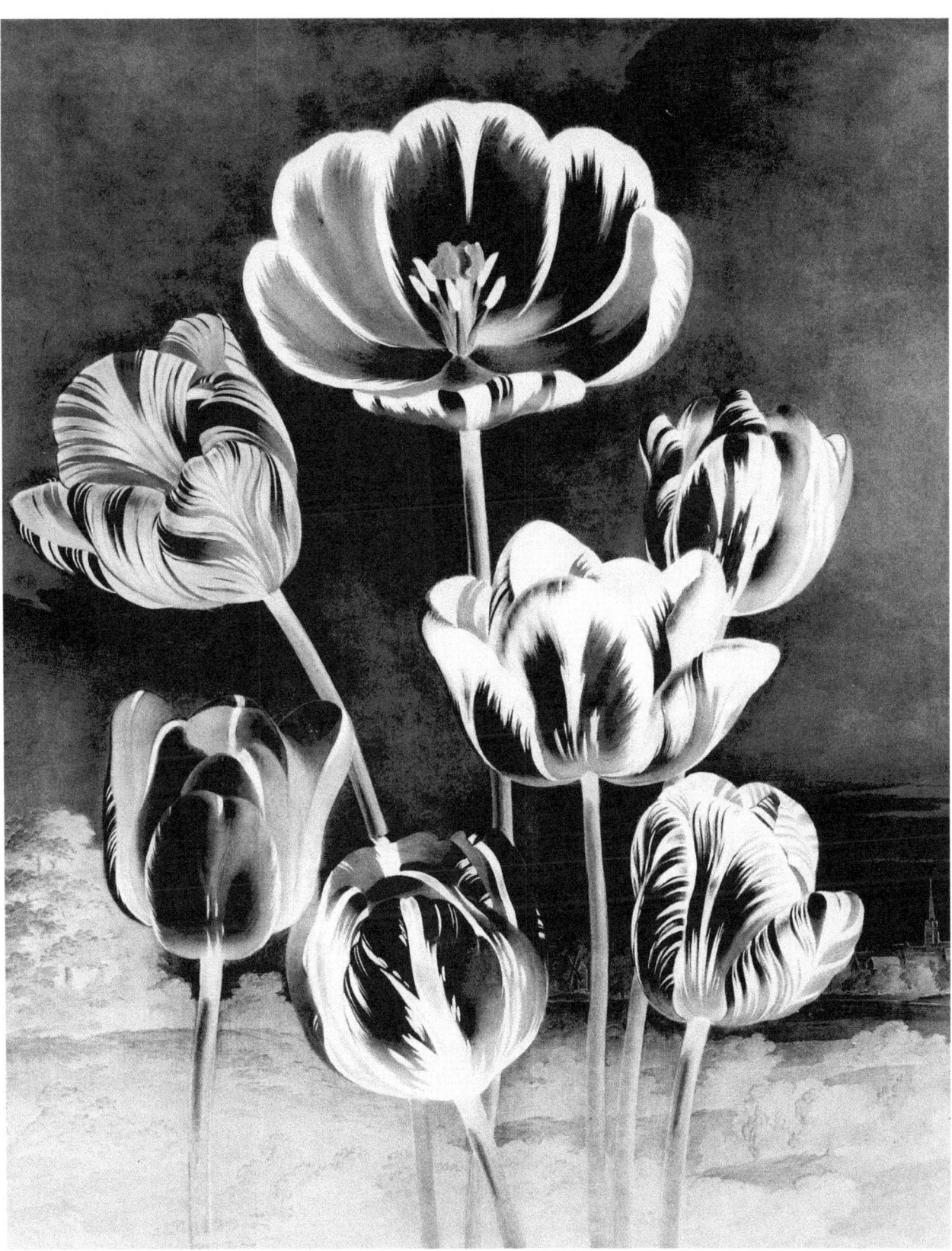

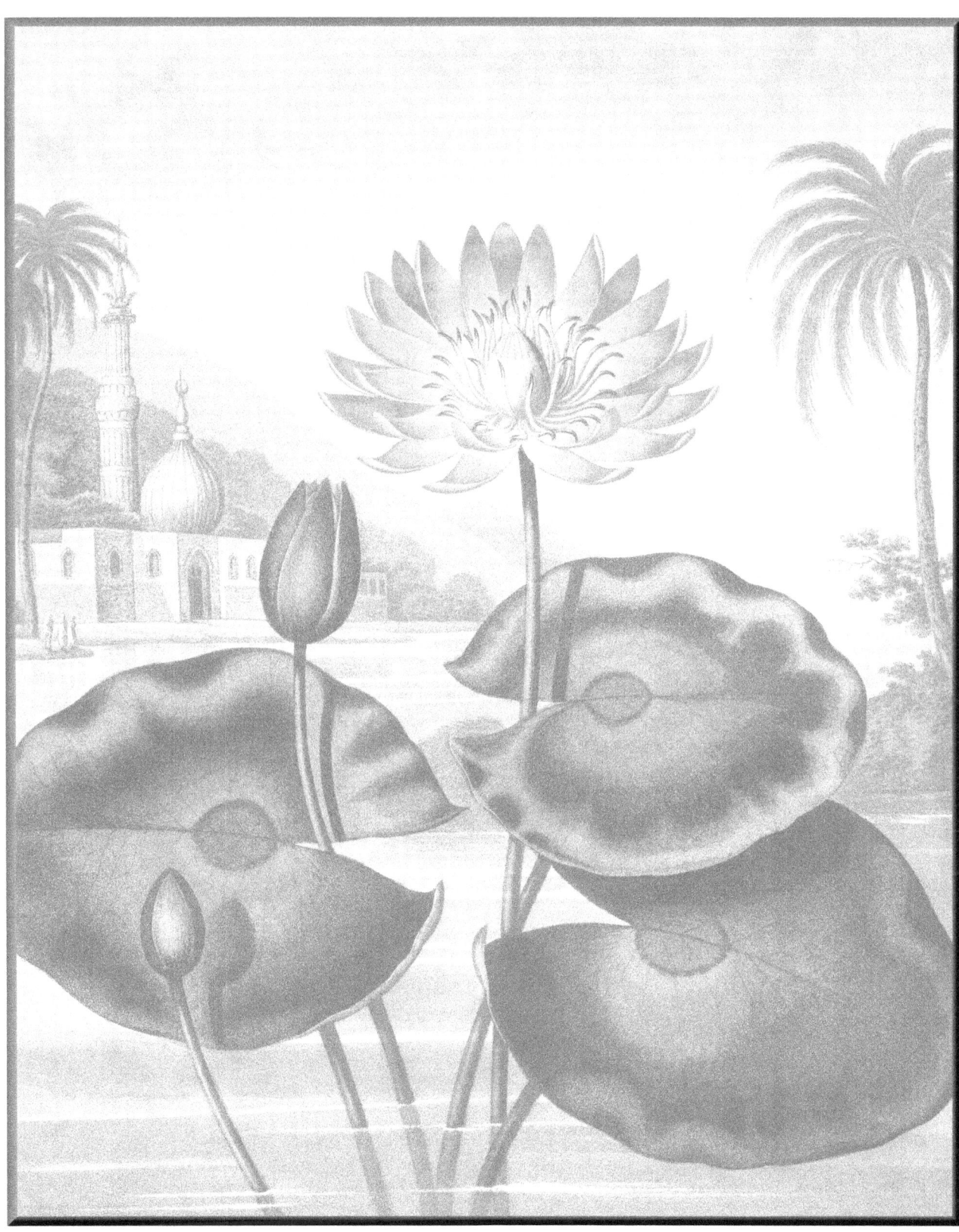

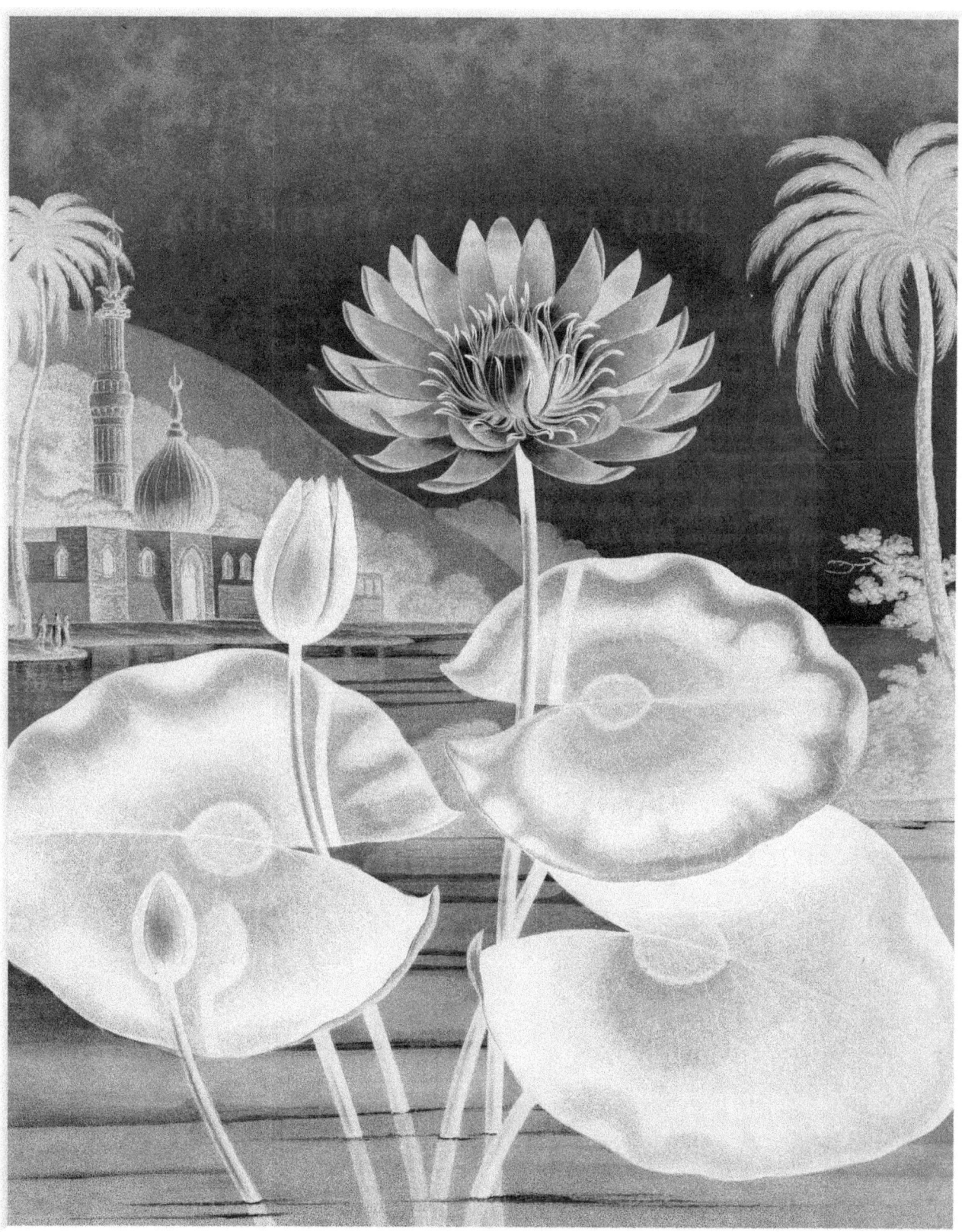

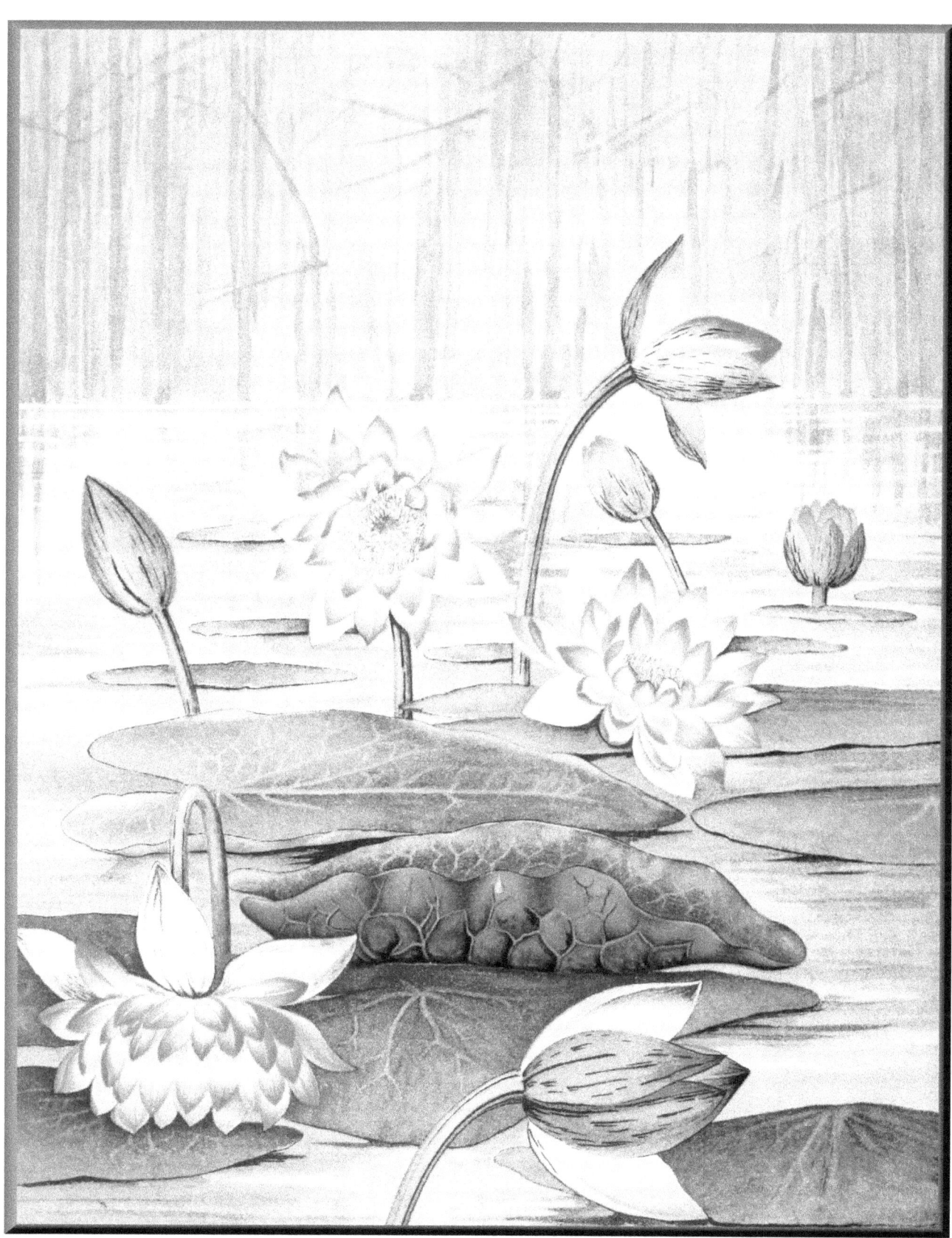

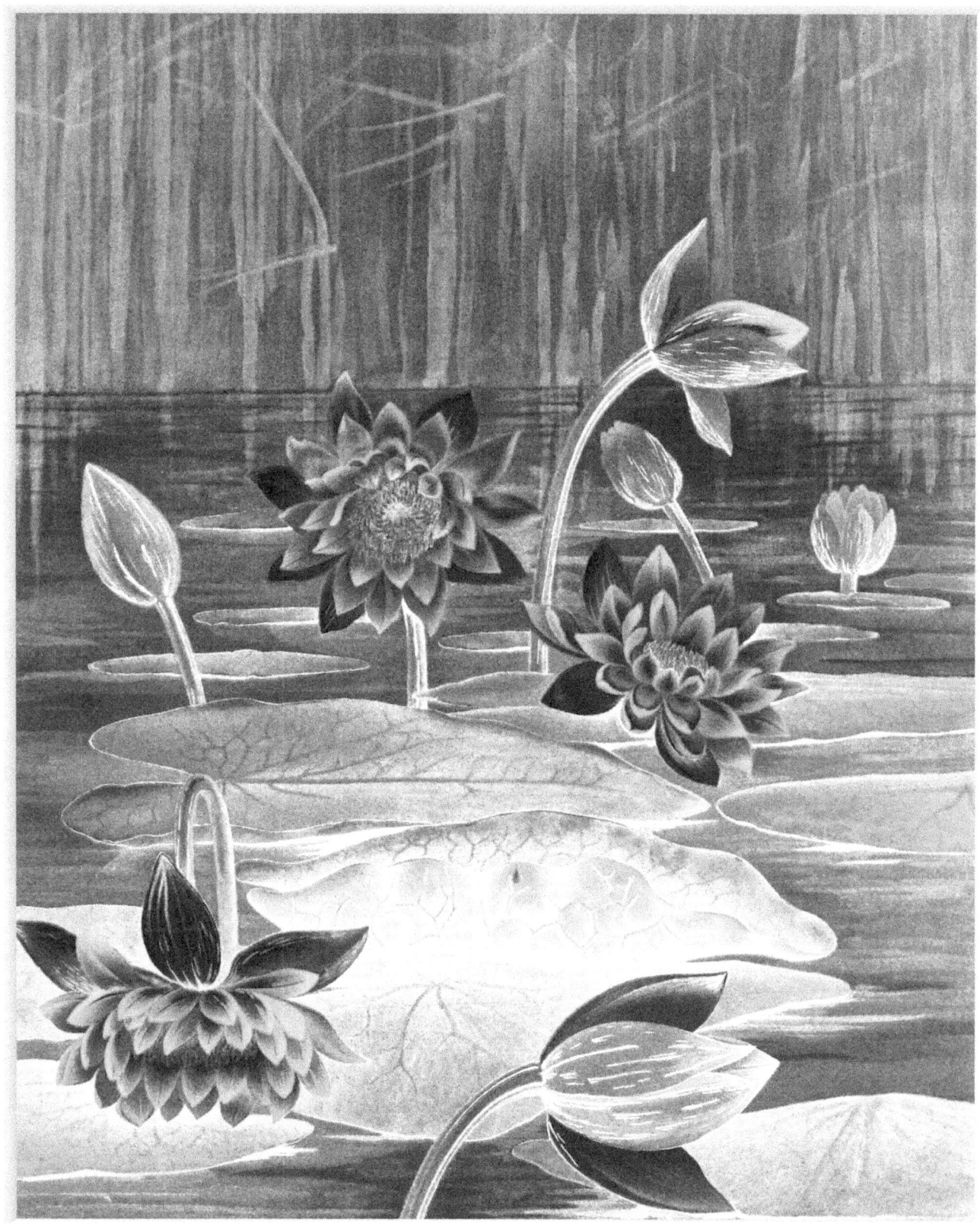

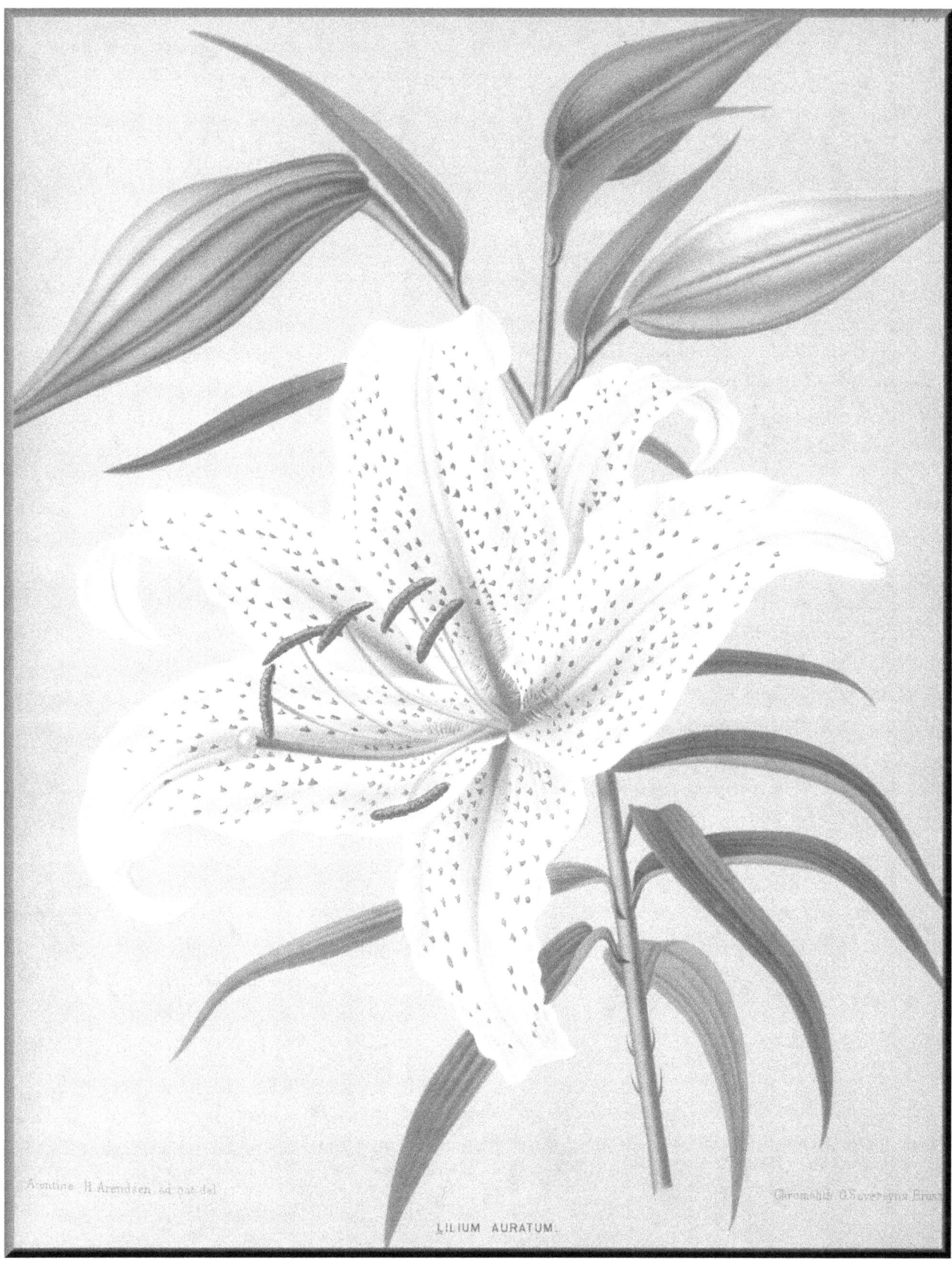

LILIUM AURATUM.

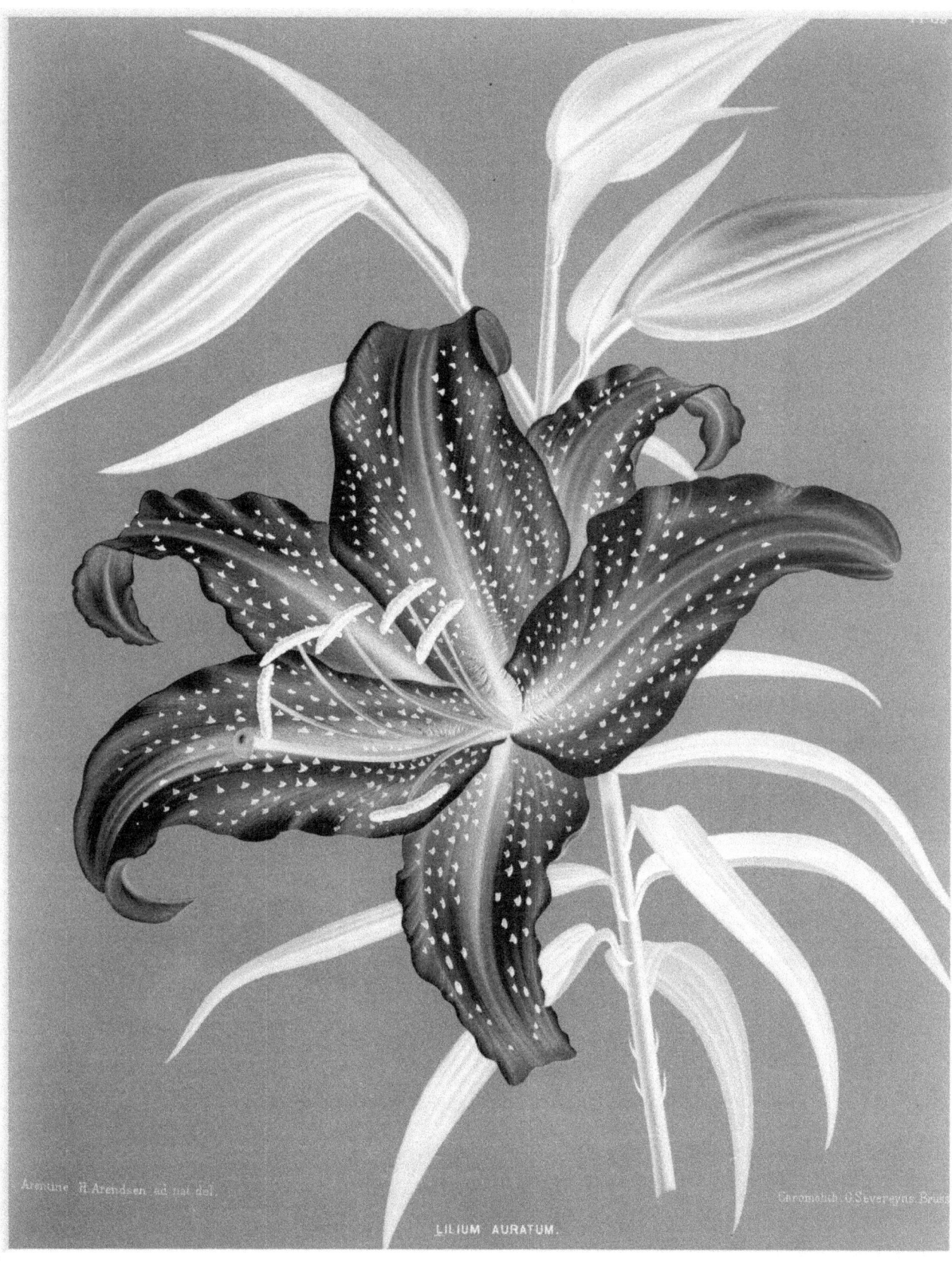

LILIUM AURATUM.

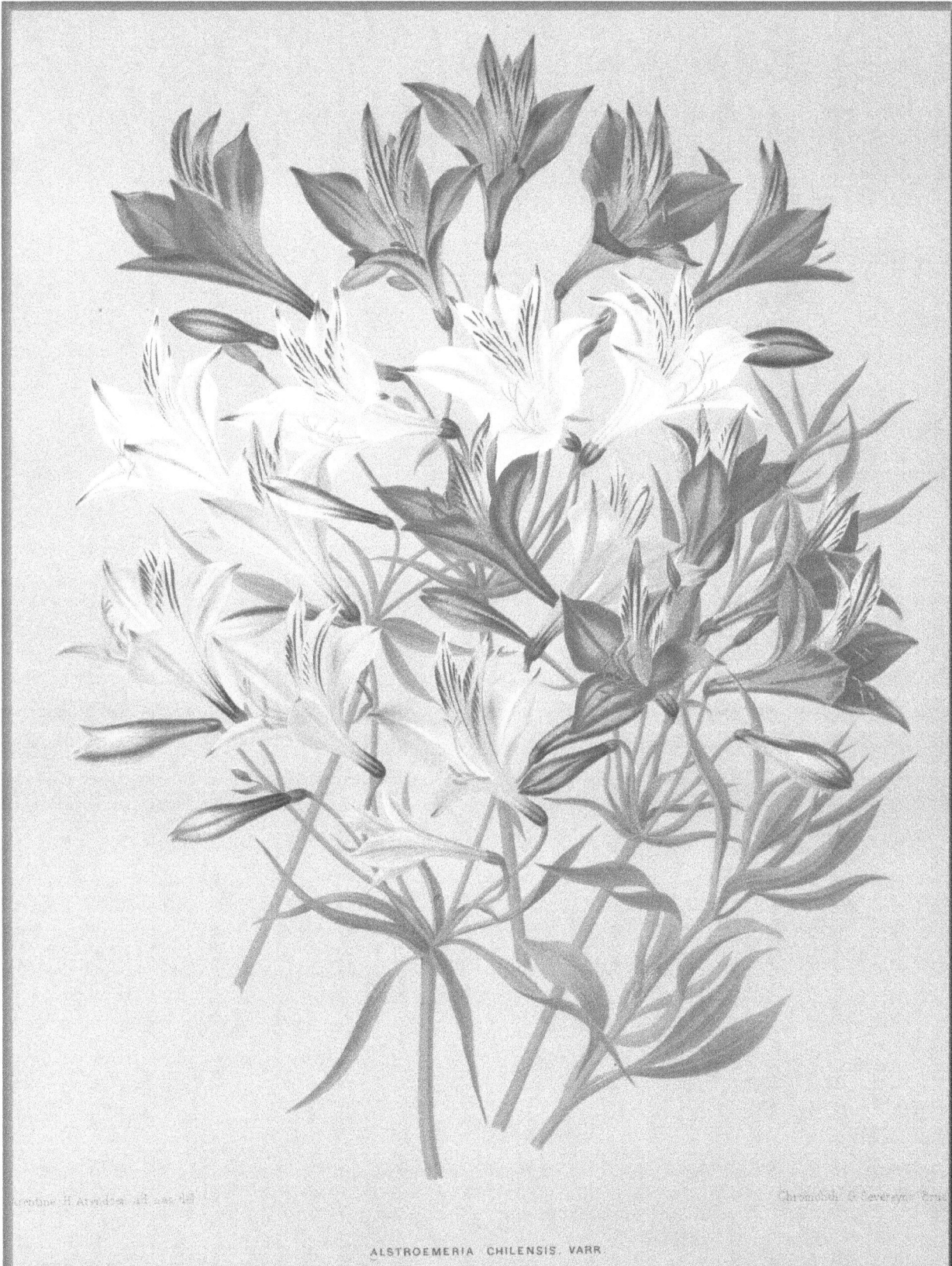

ALSTROEMERIA CHILENSIS, VARR.

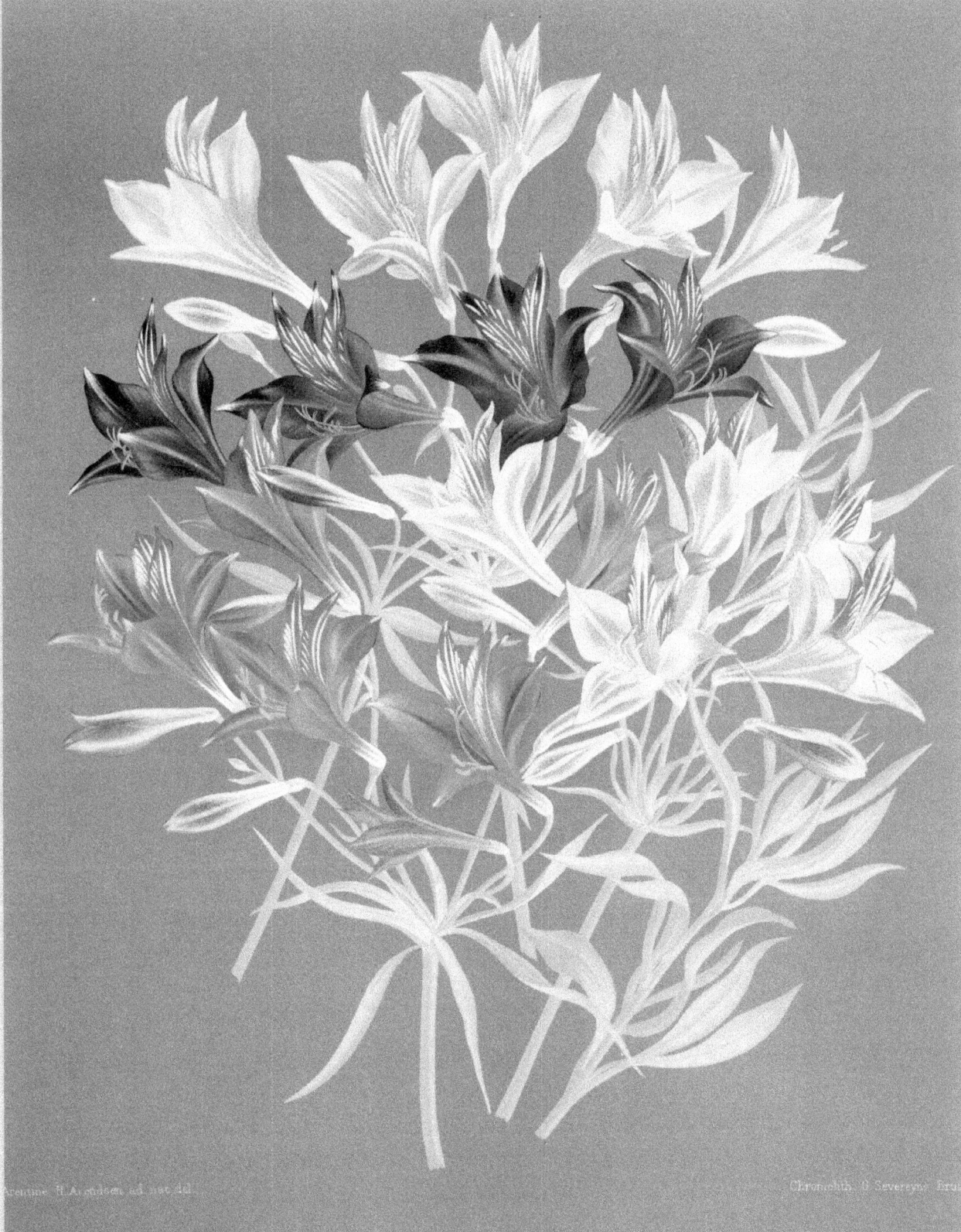

ALSTROEMERIA CHILENSIS. VARR.

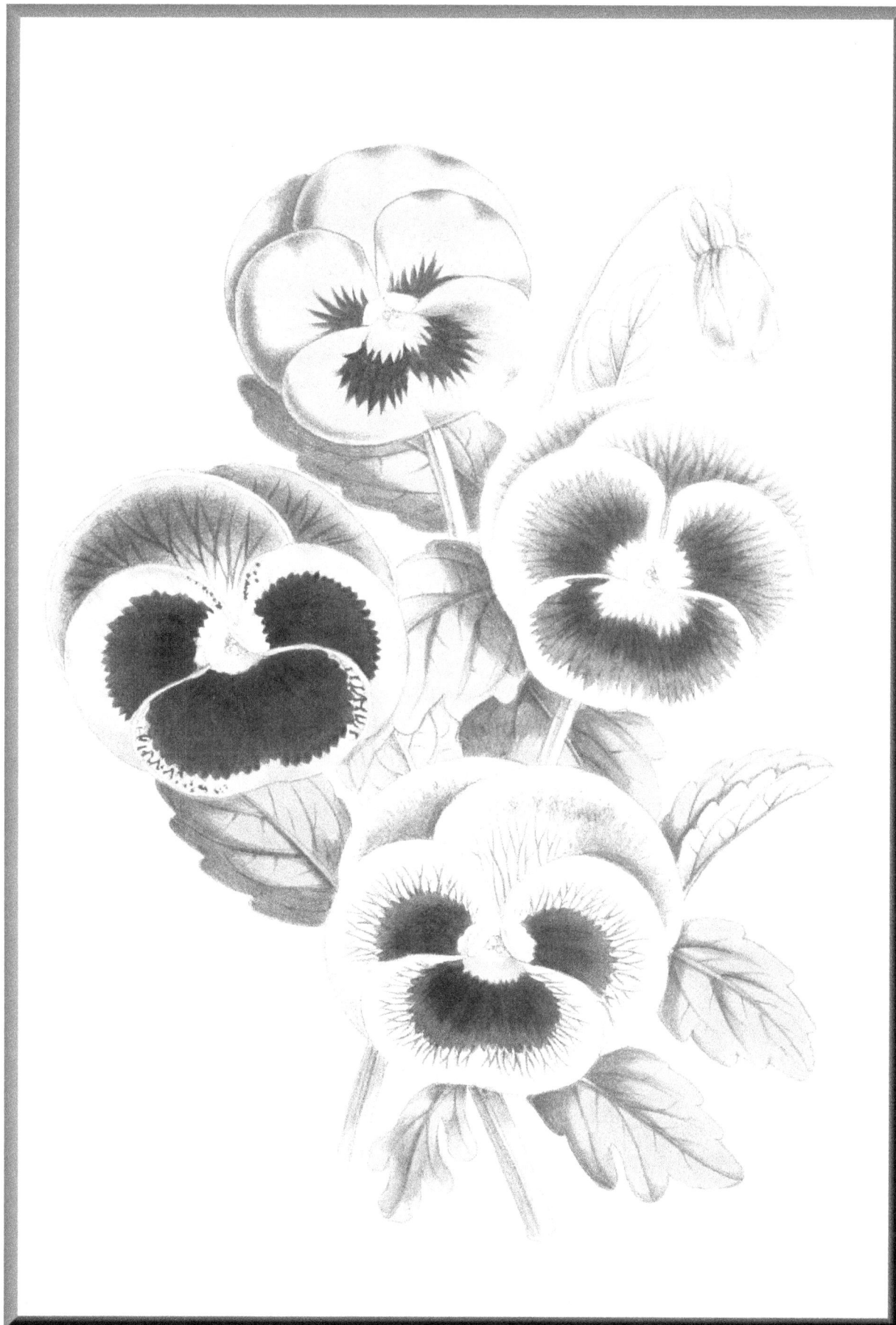

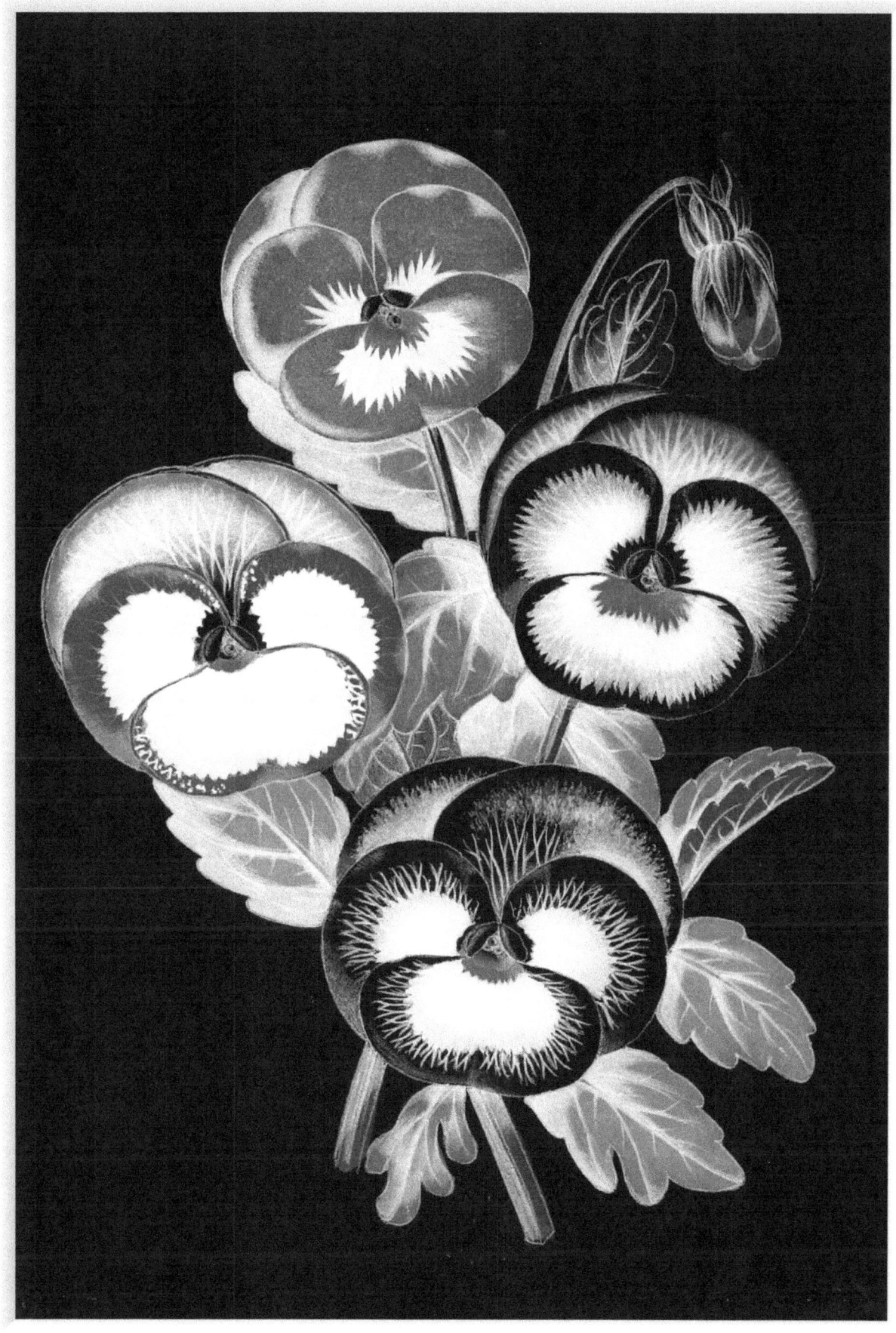

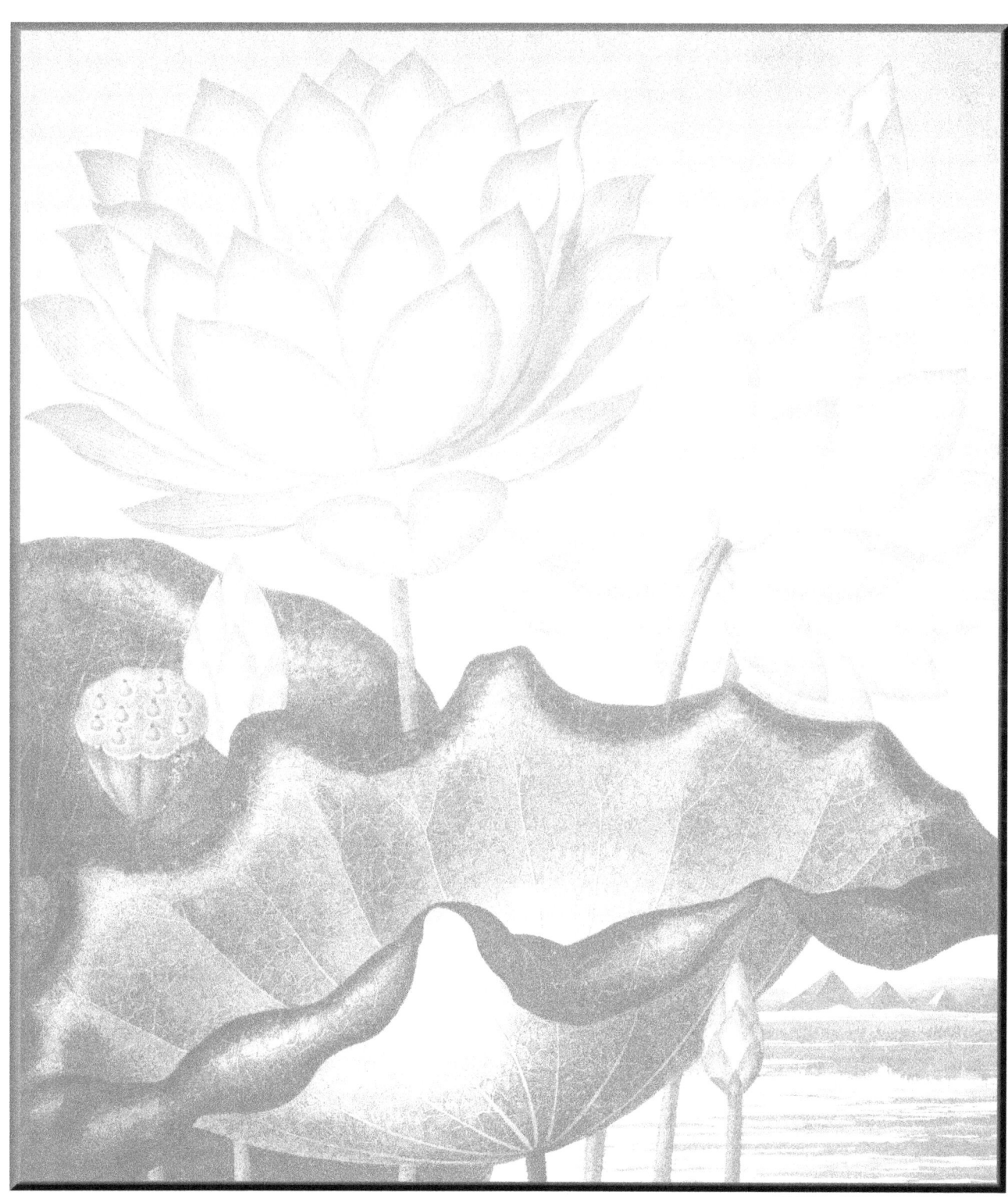

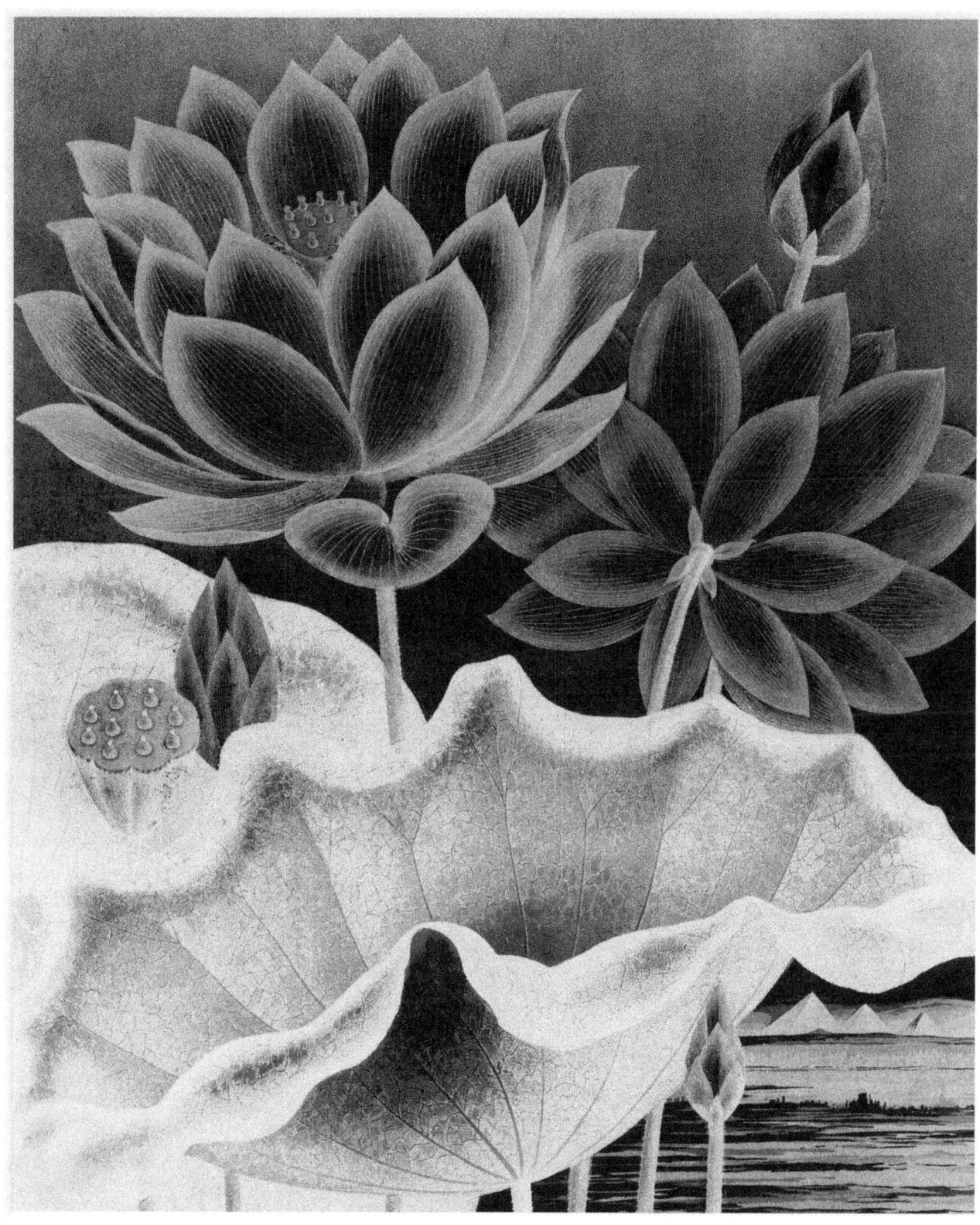

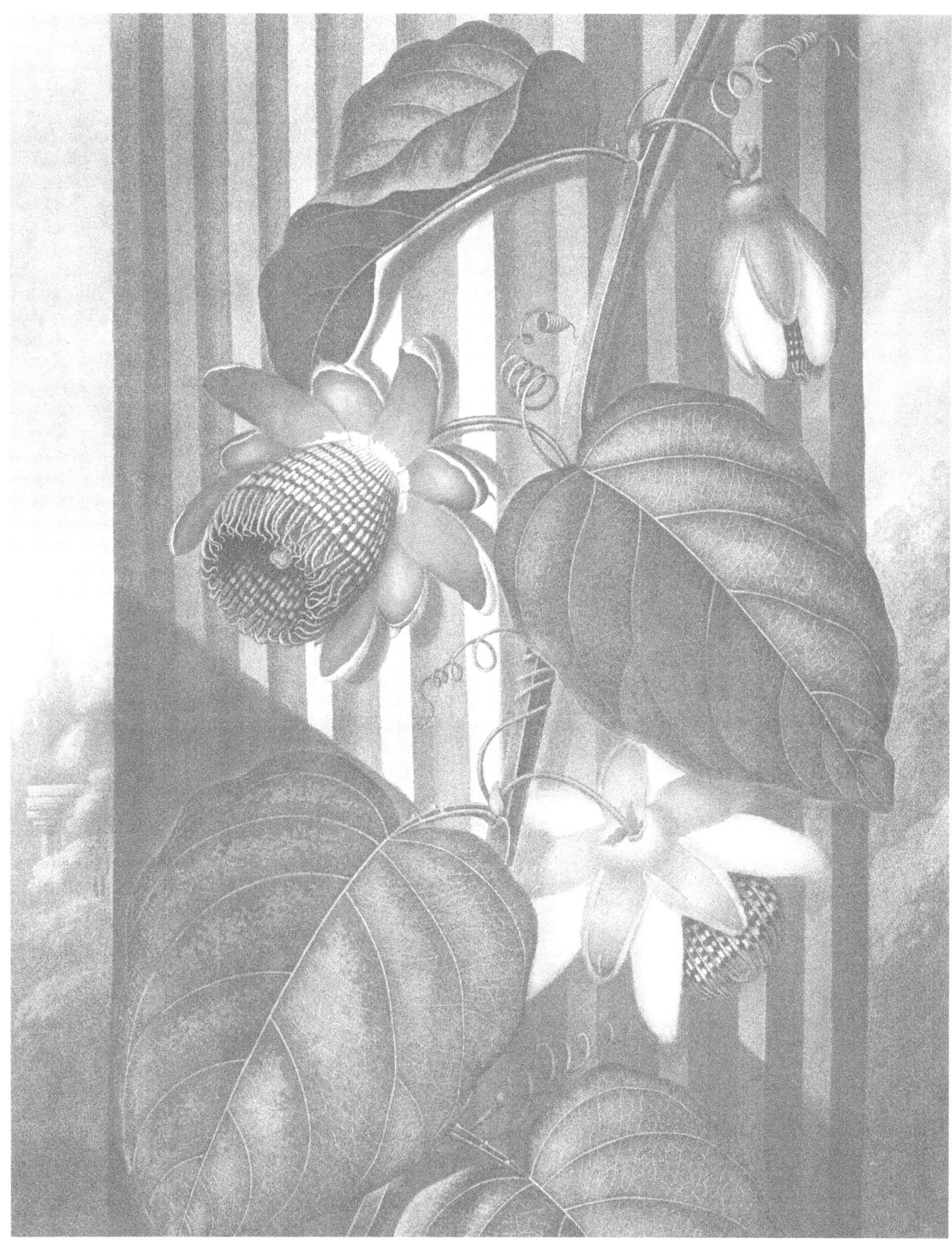

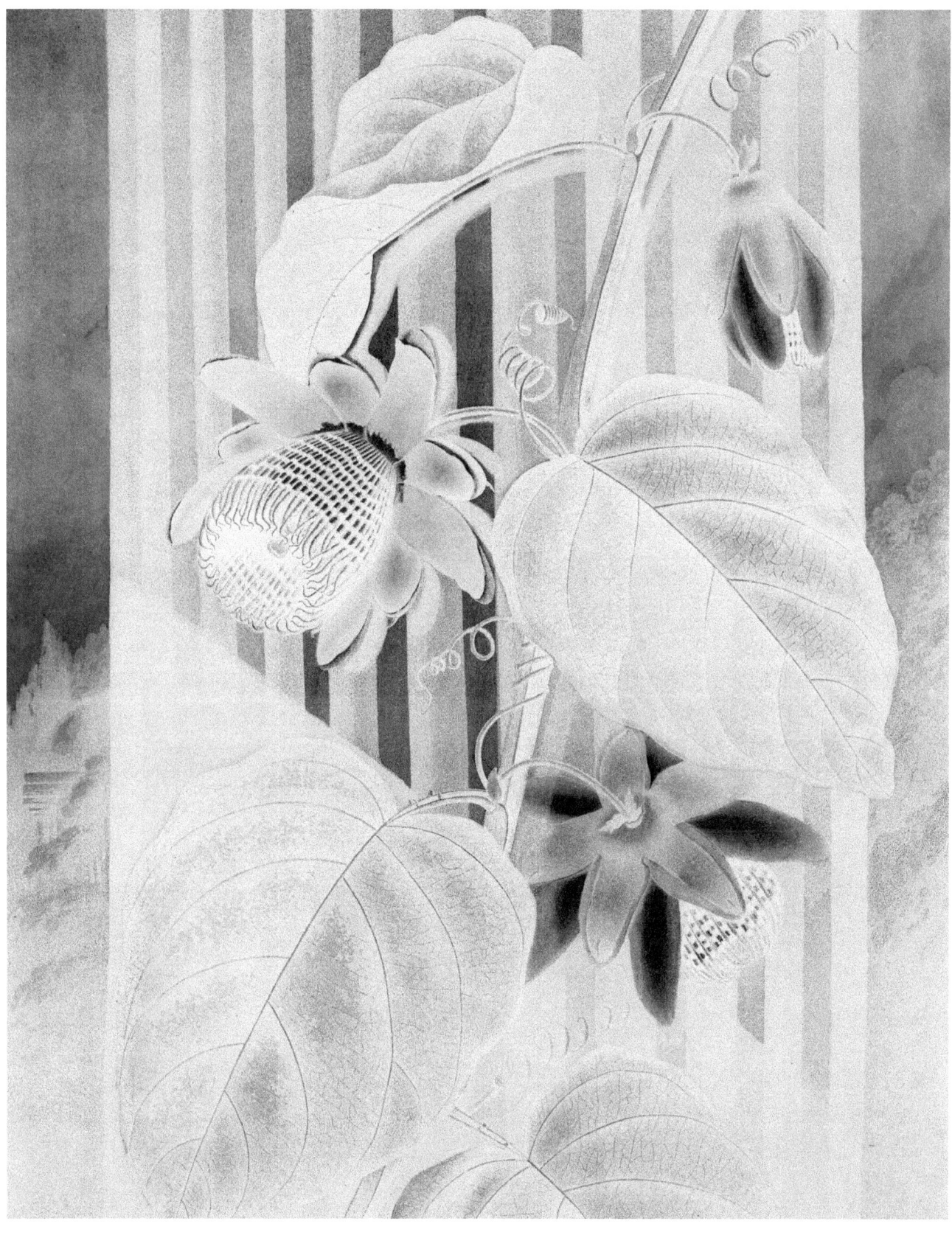

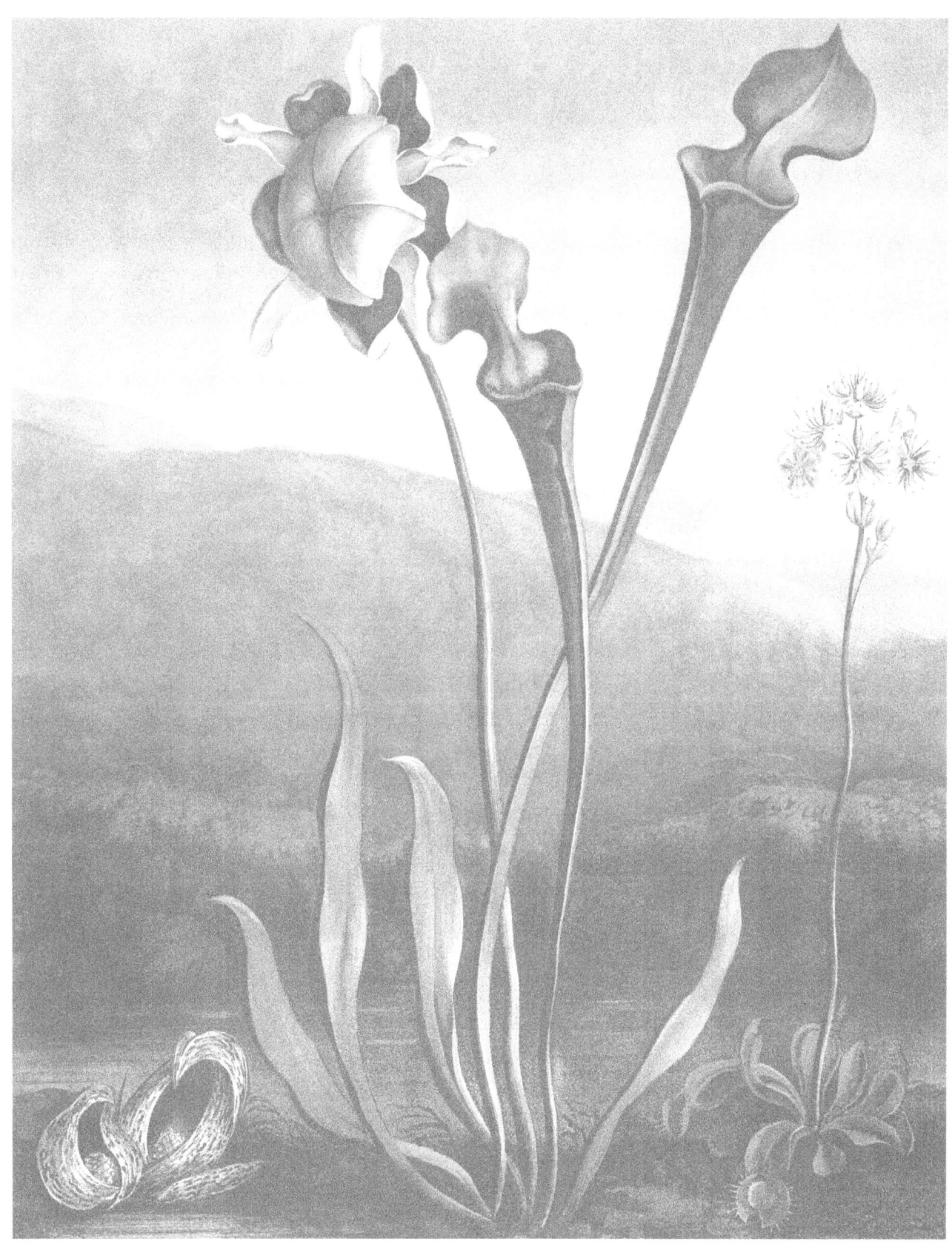

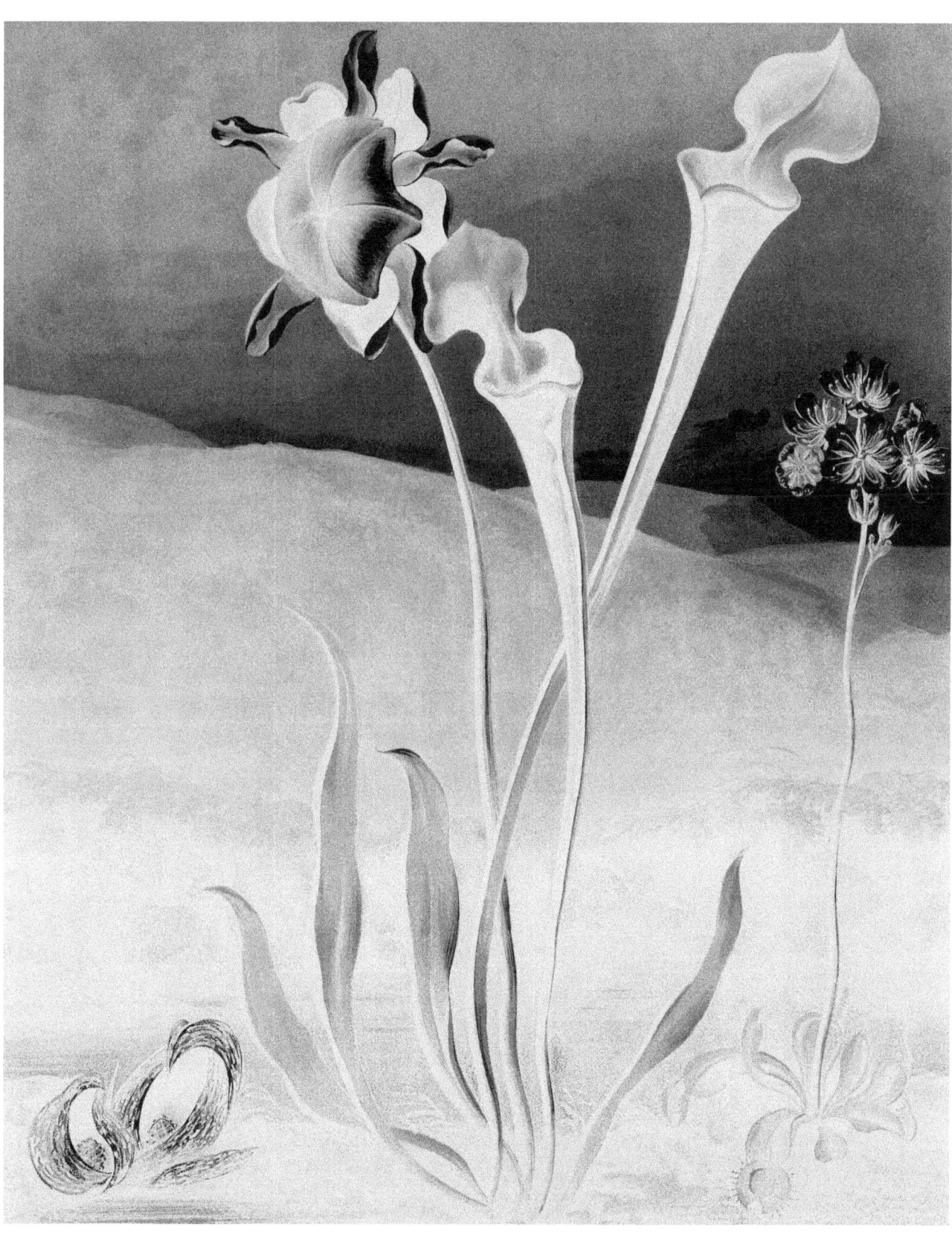

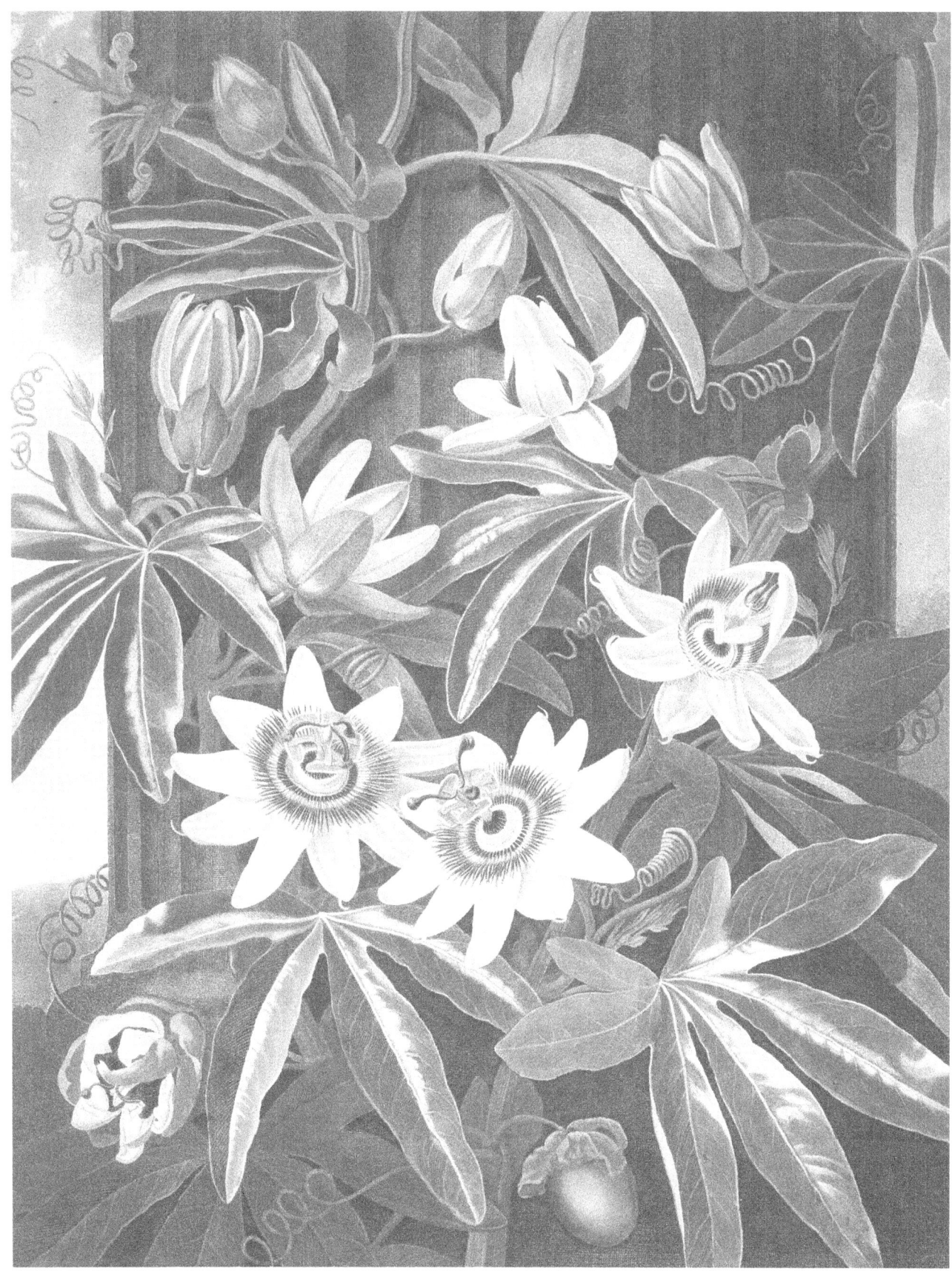

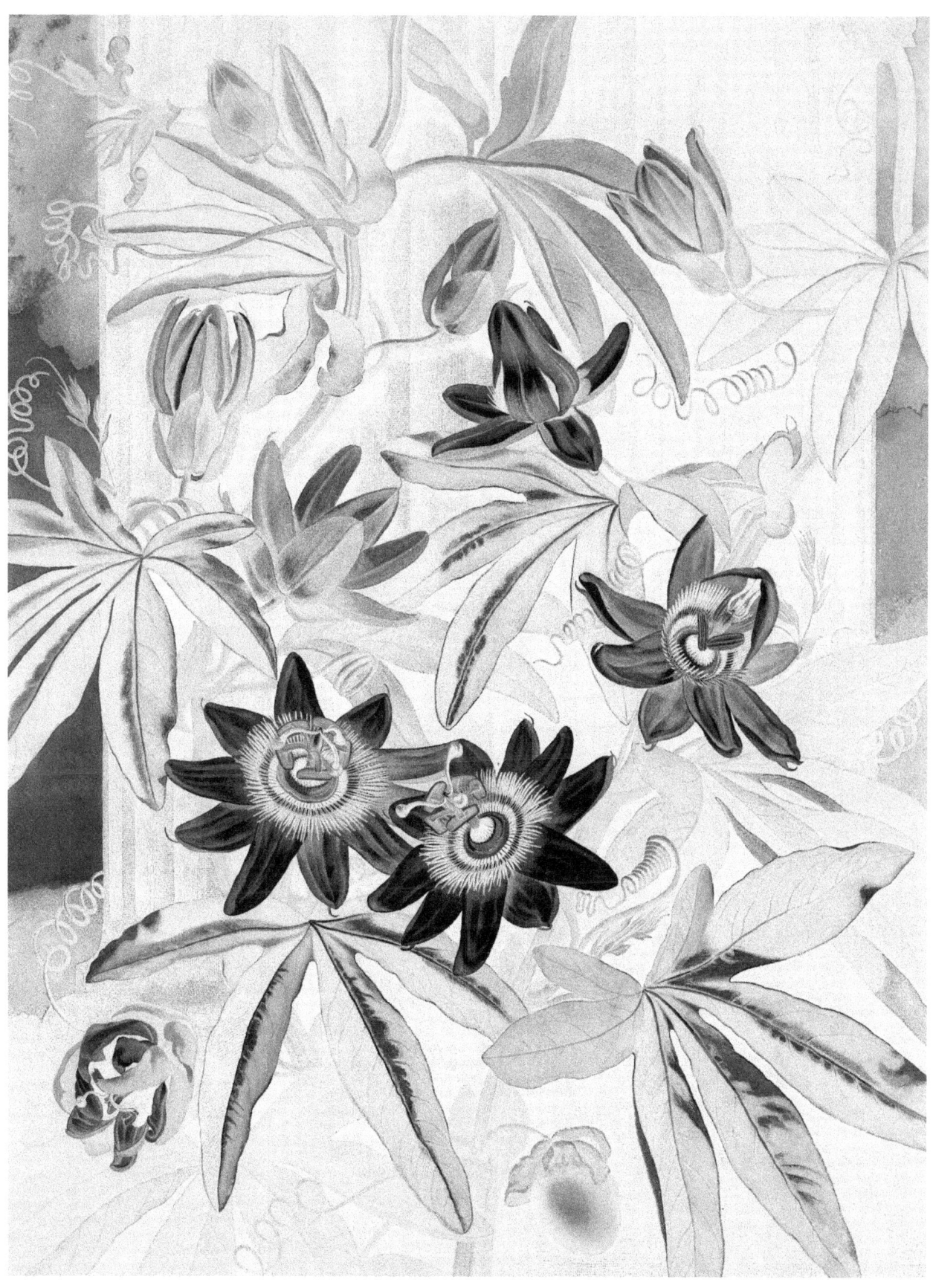

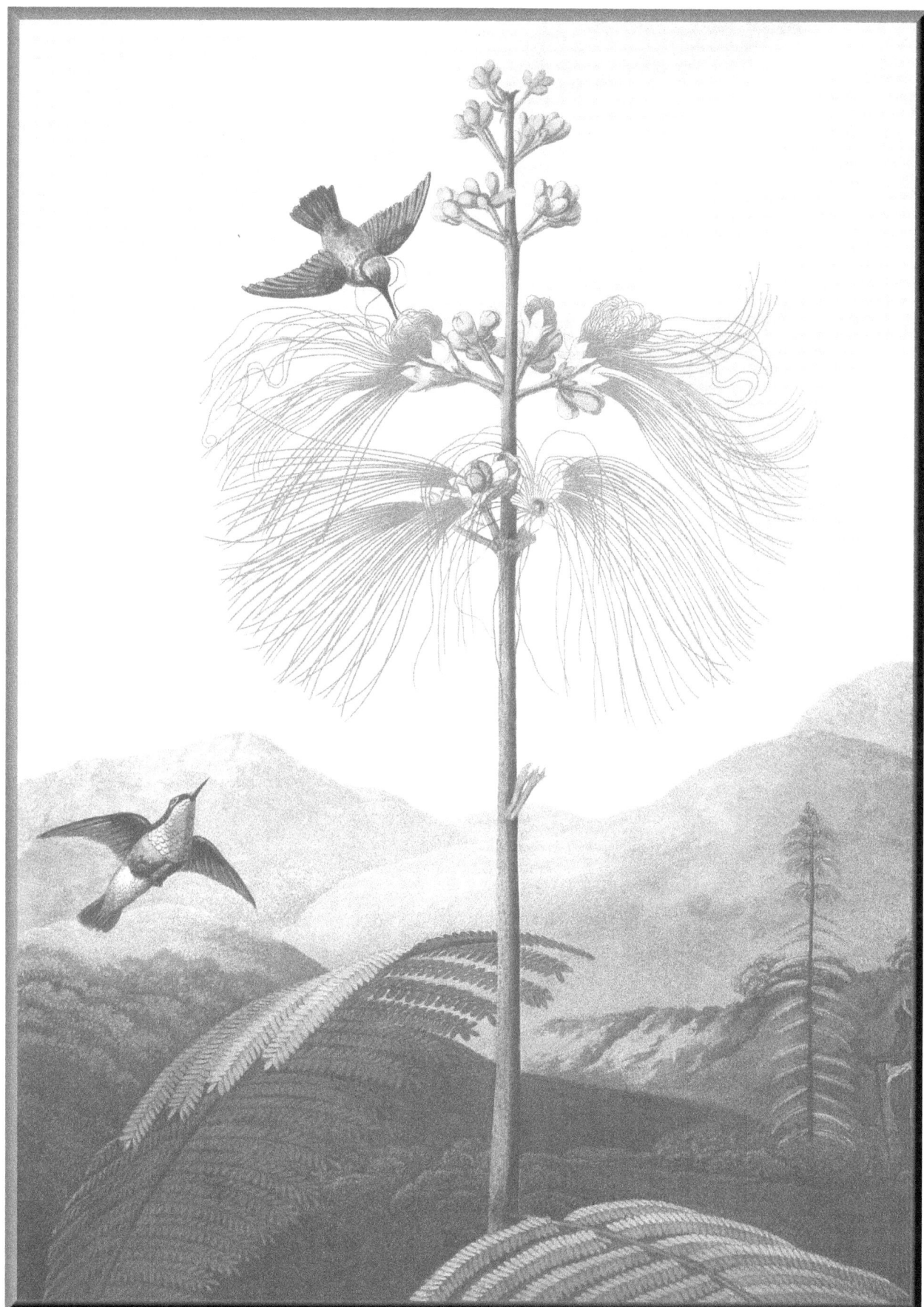

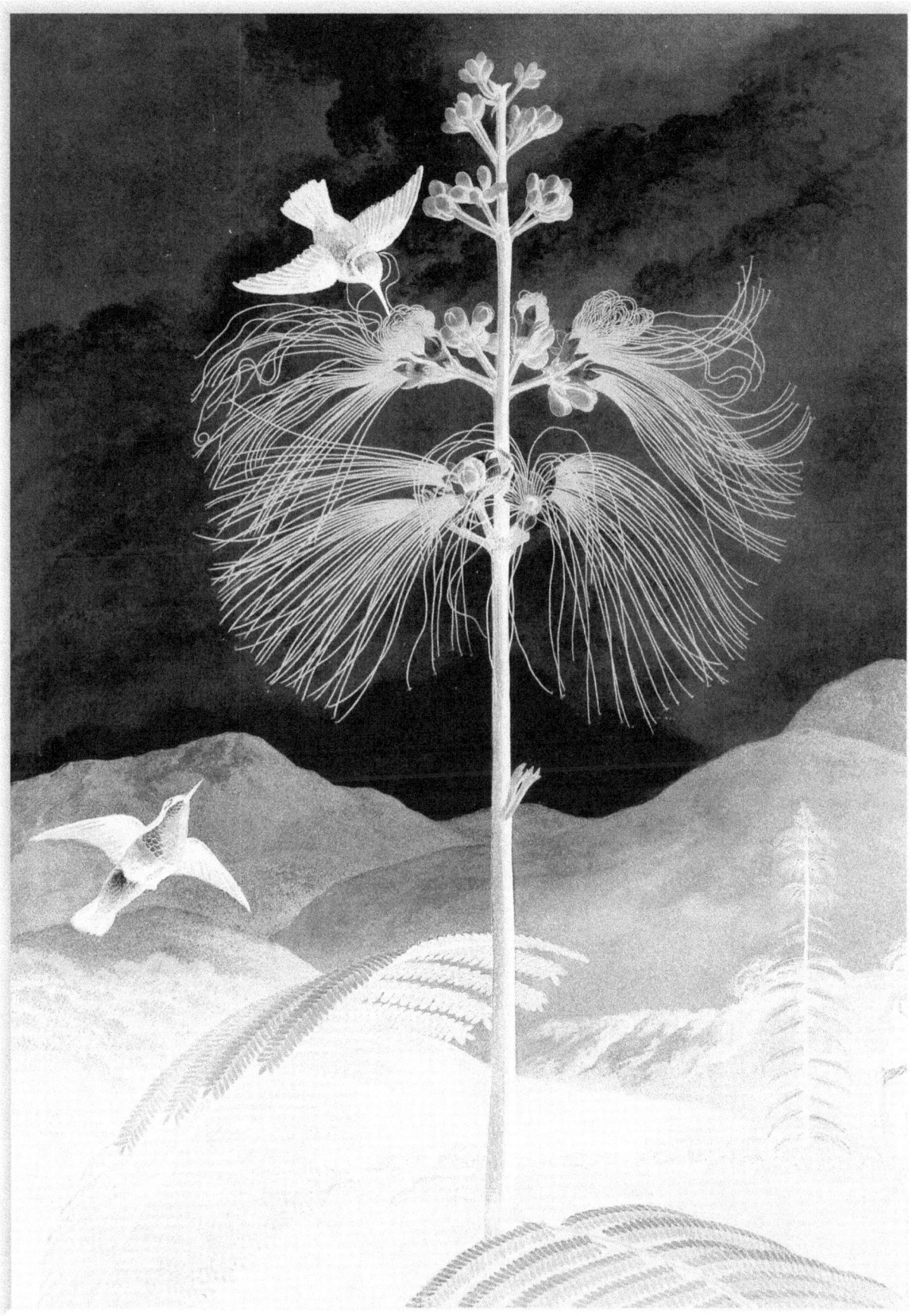

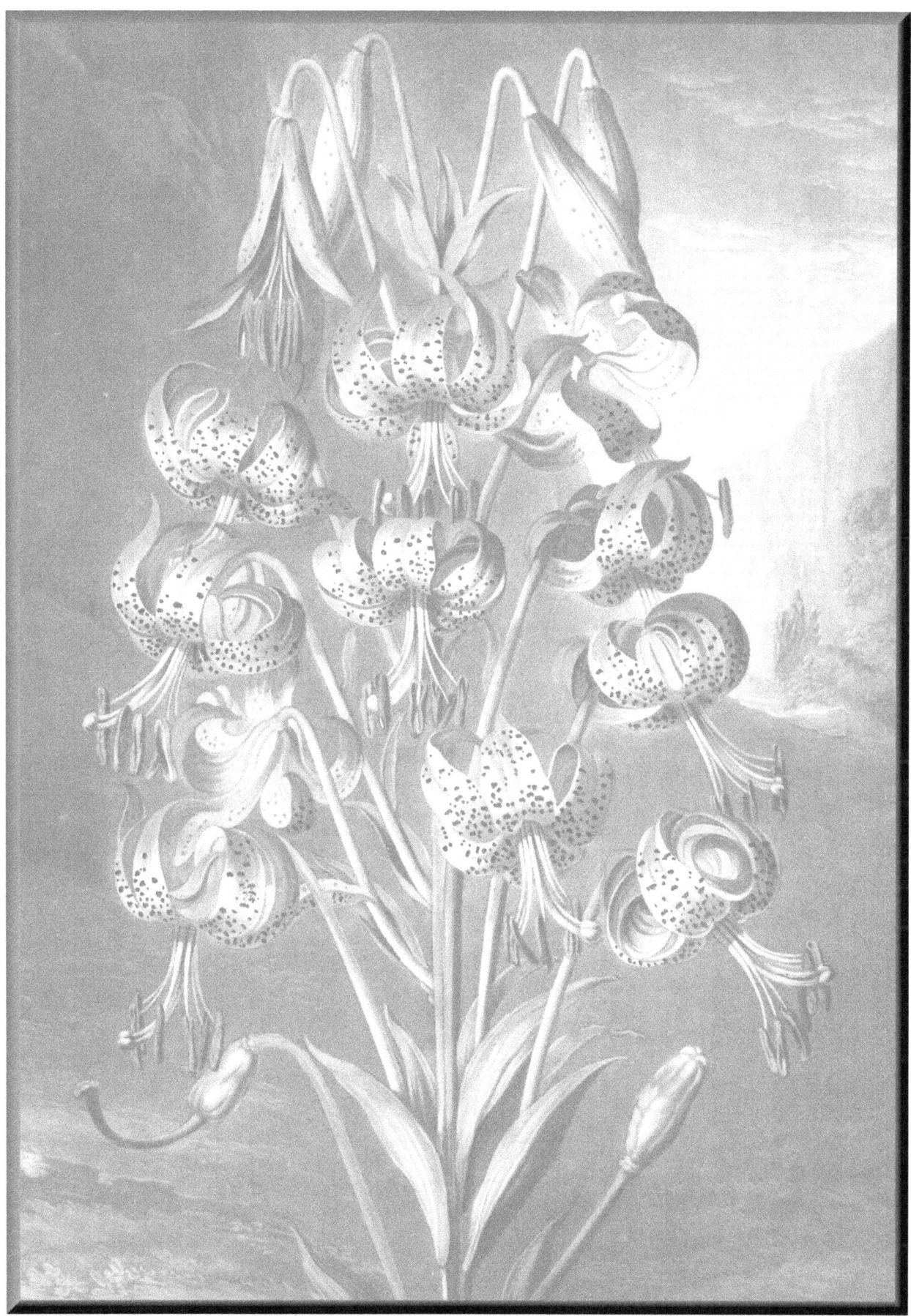

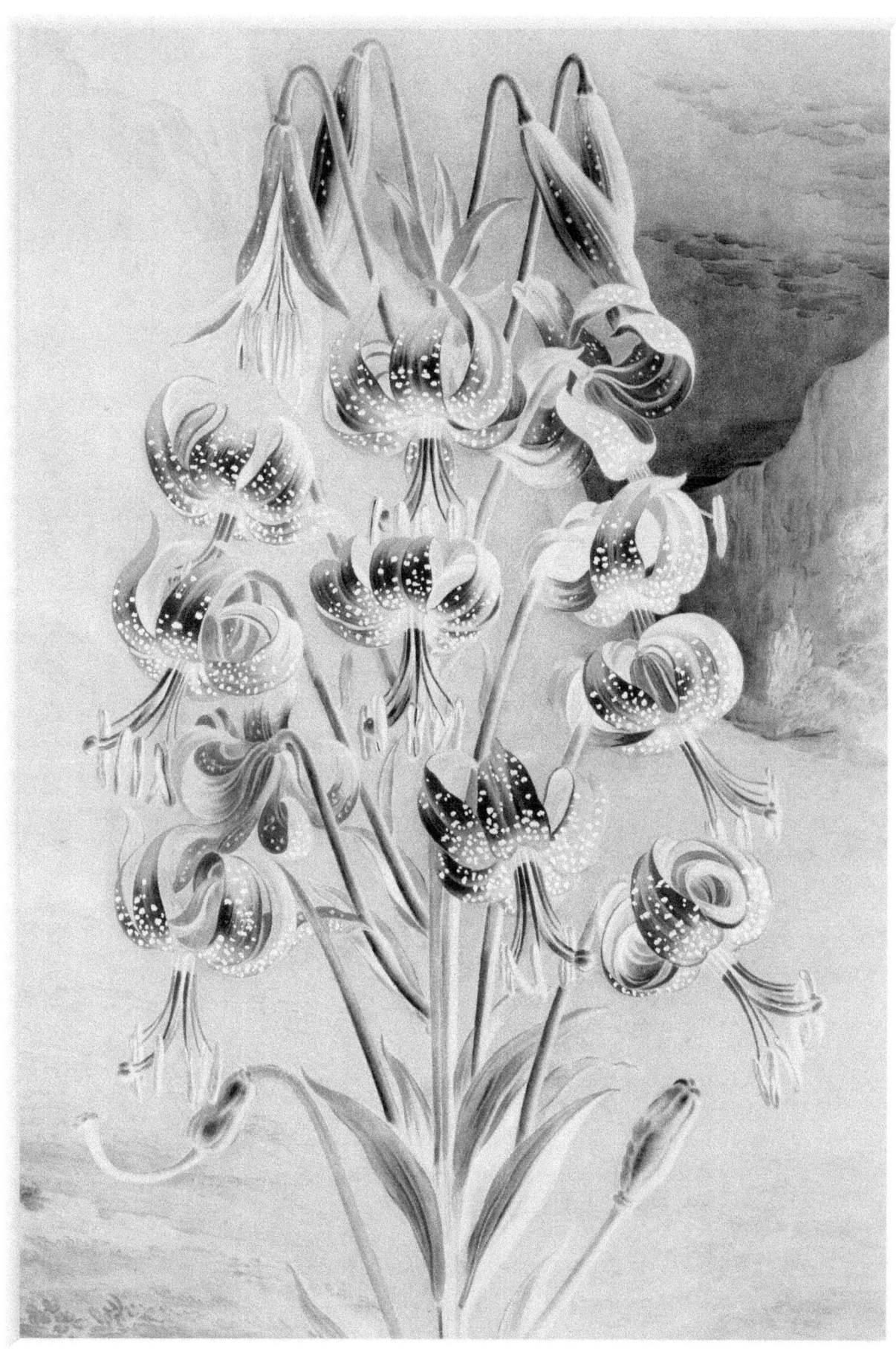

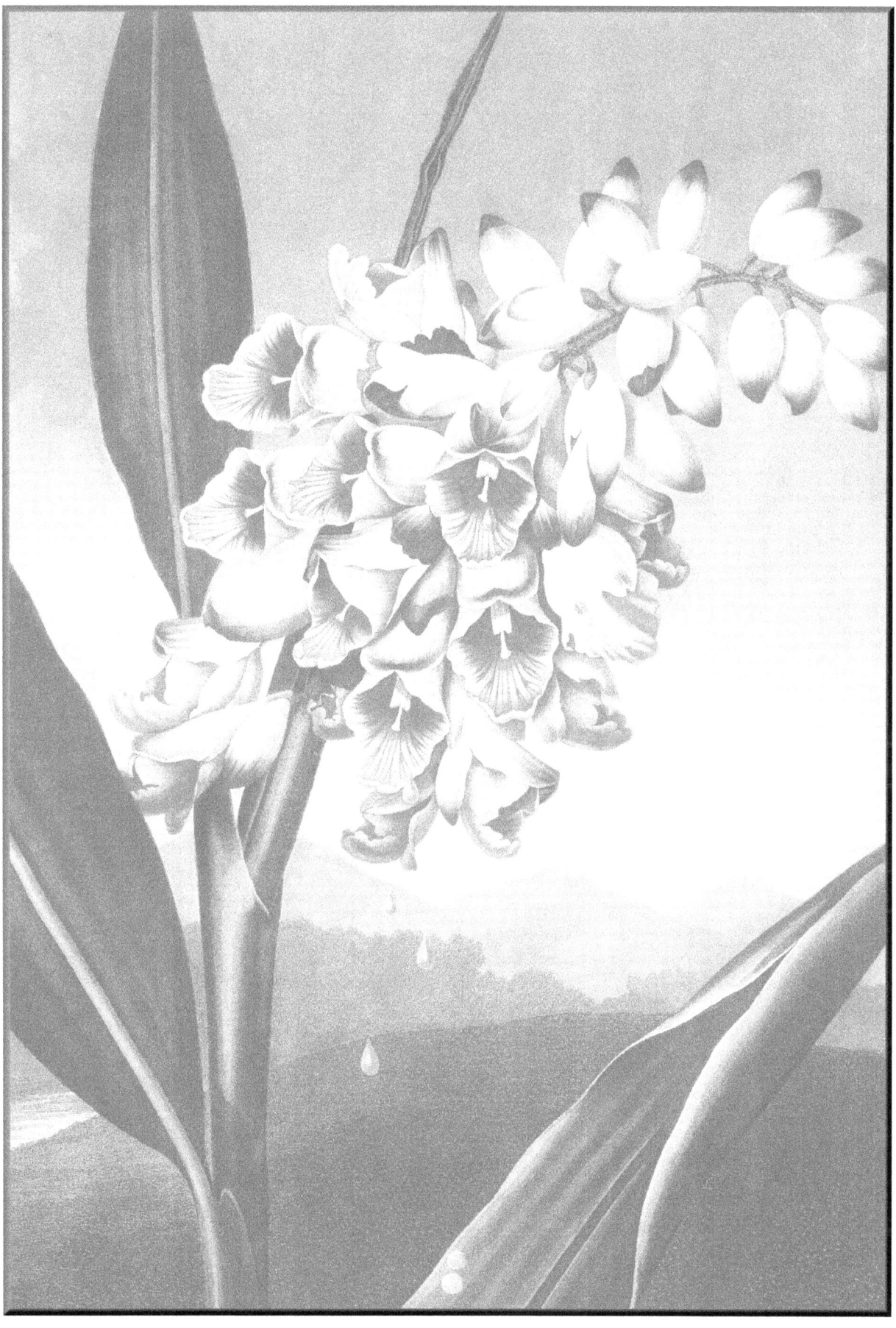

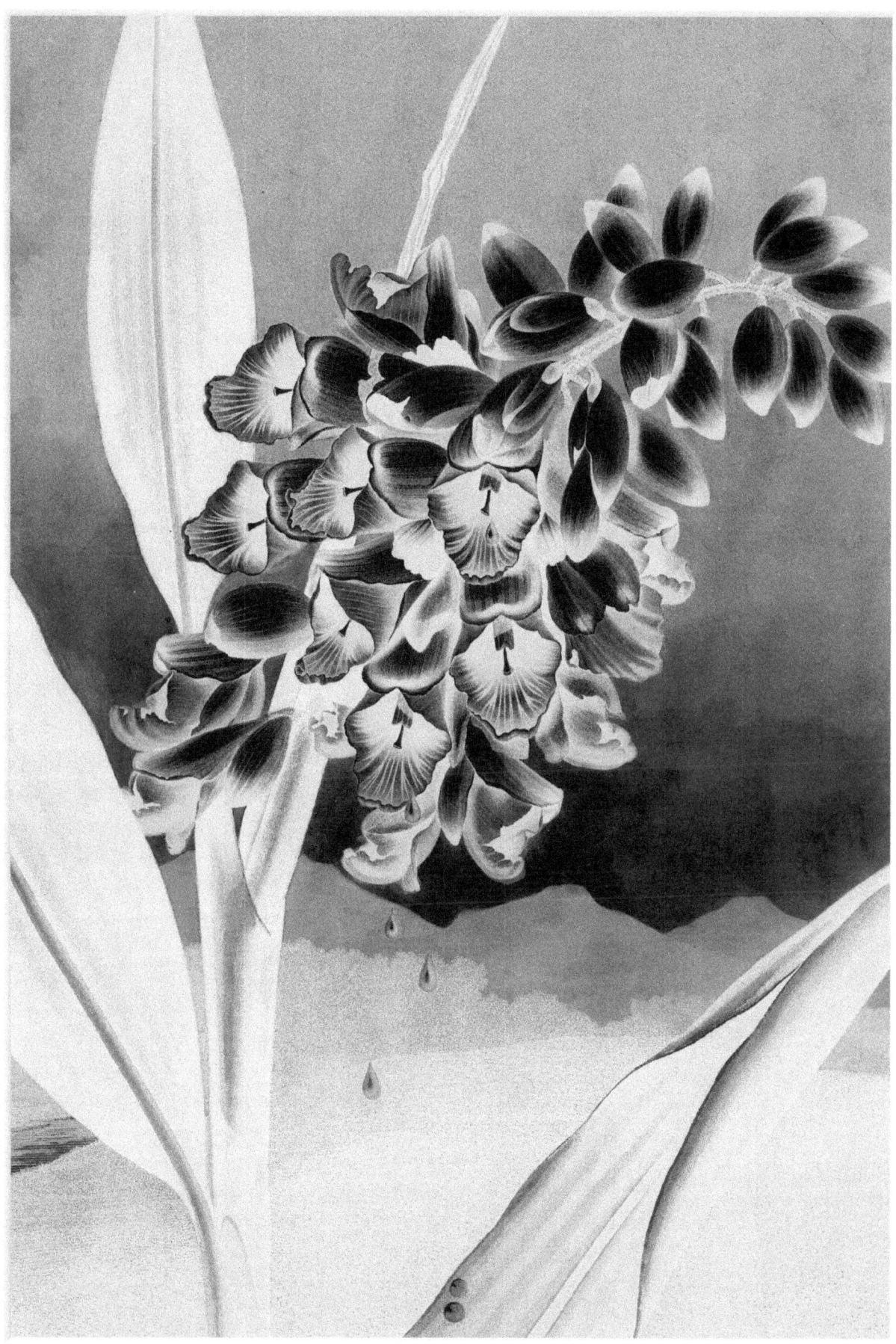

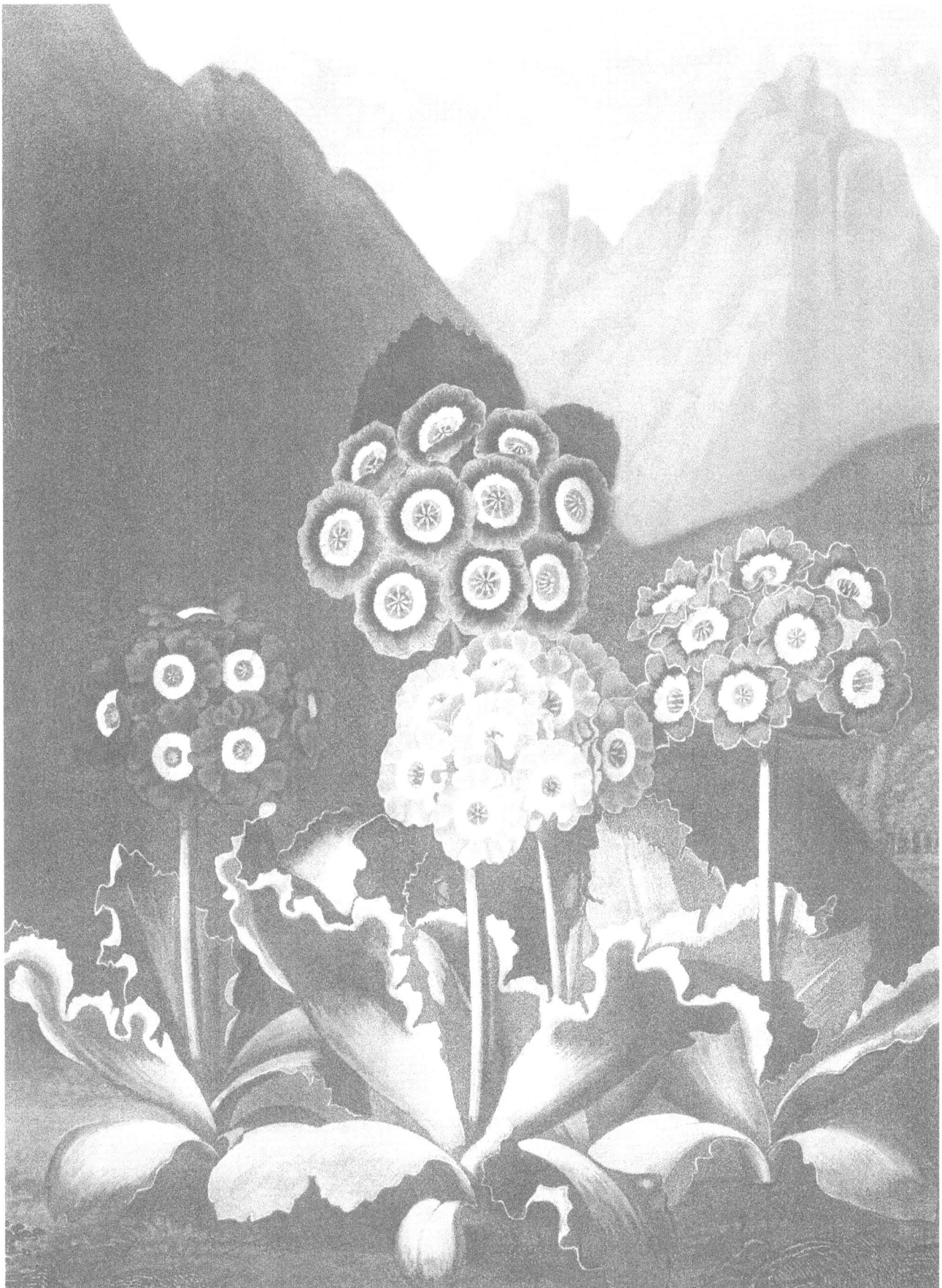

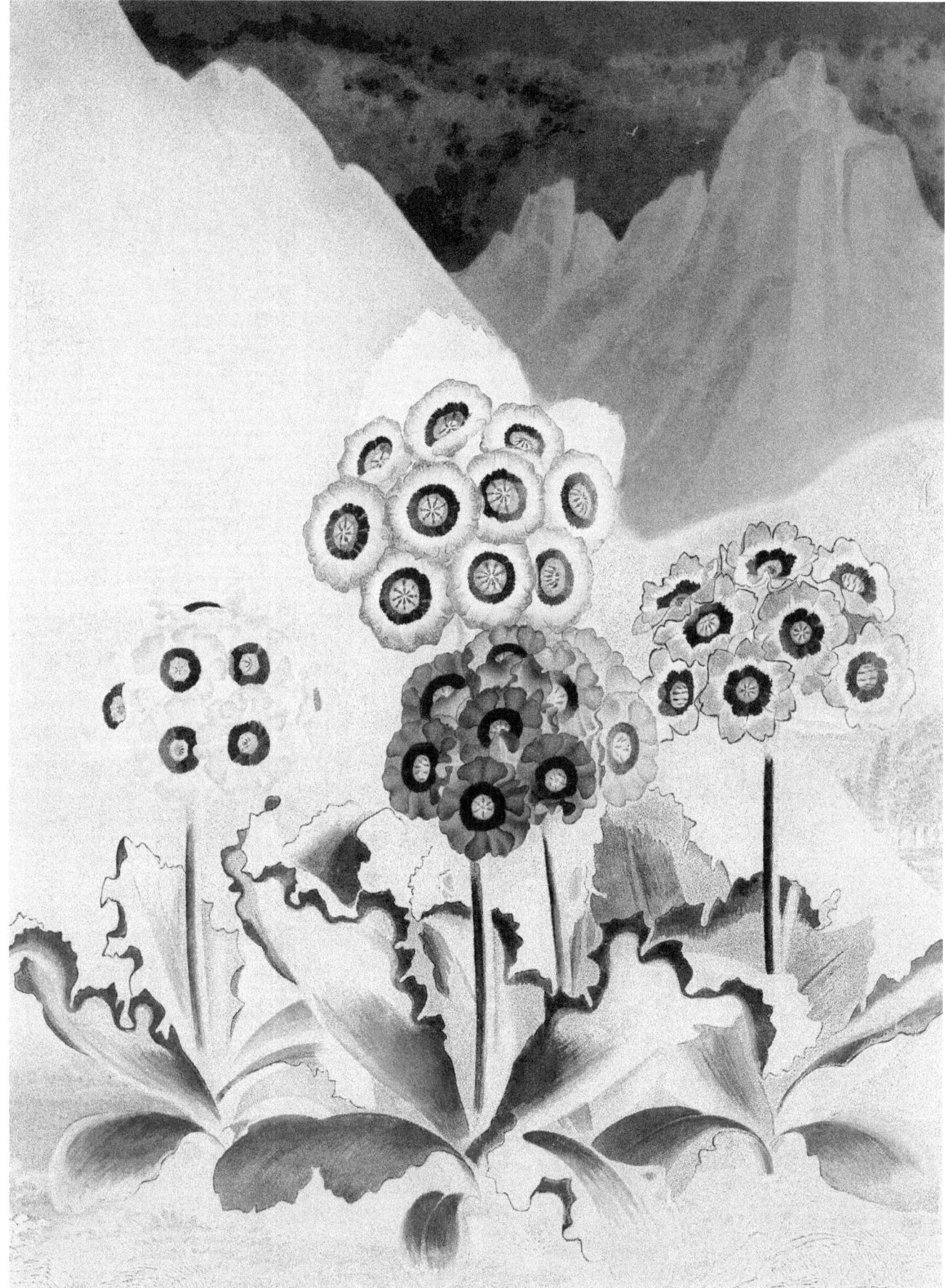

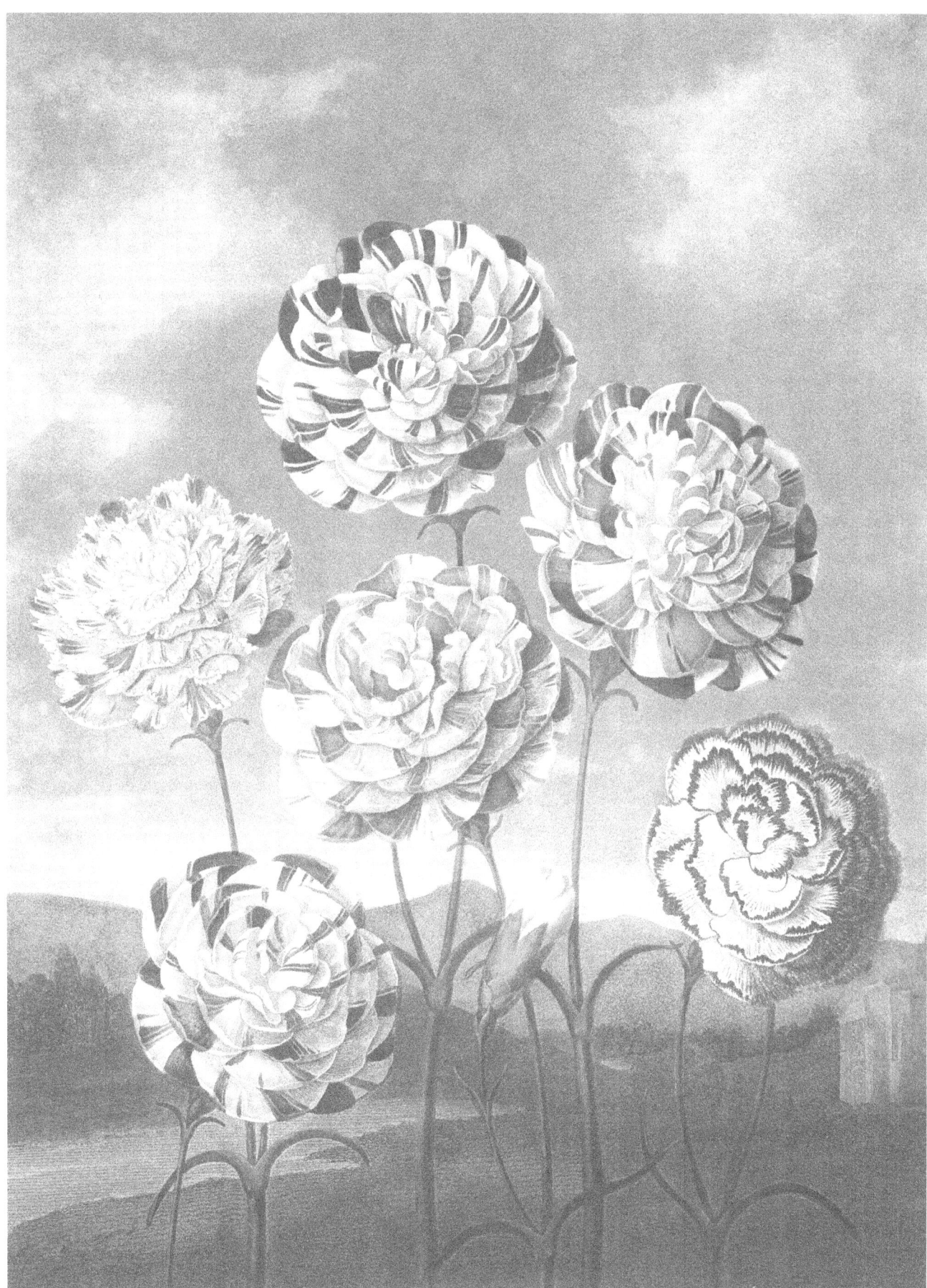

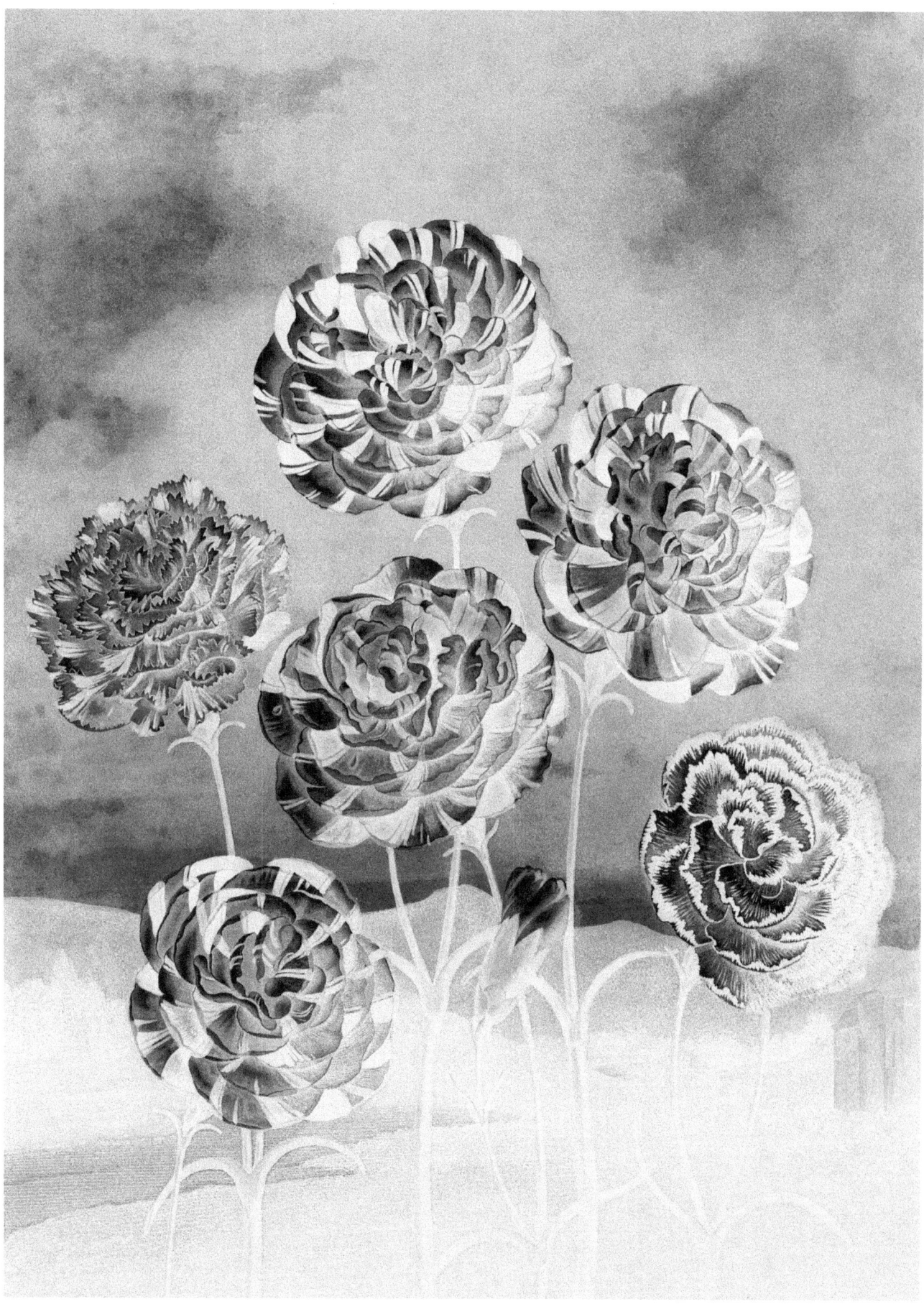

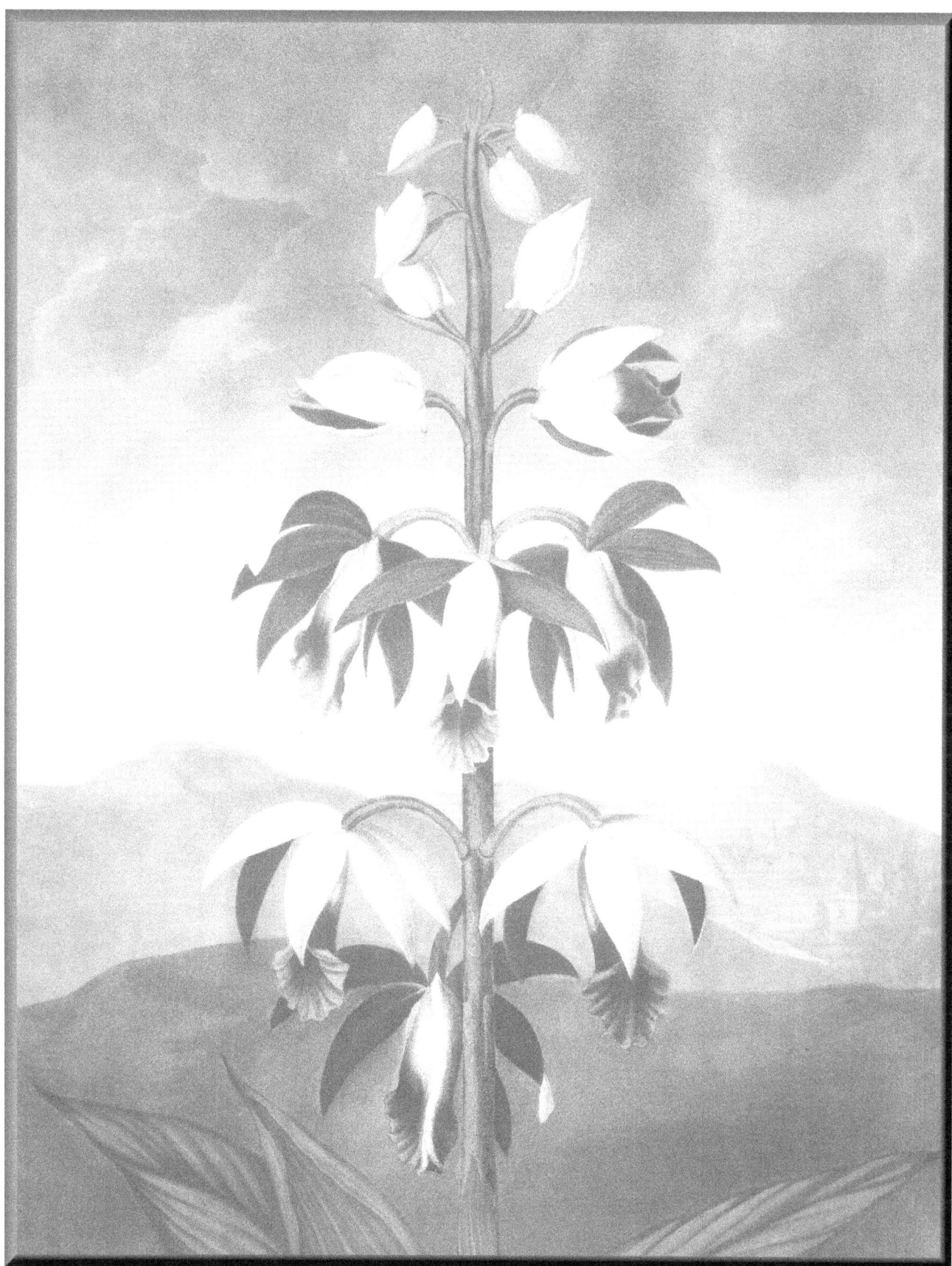

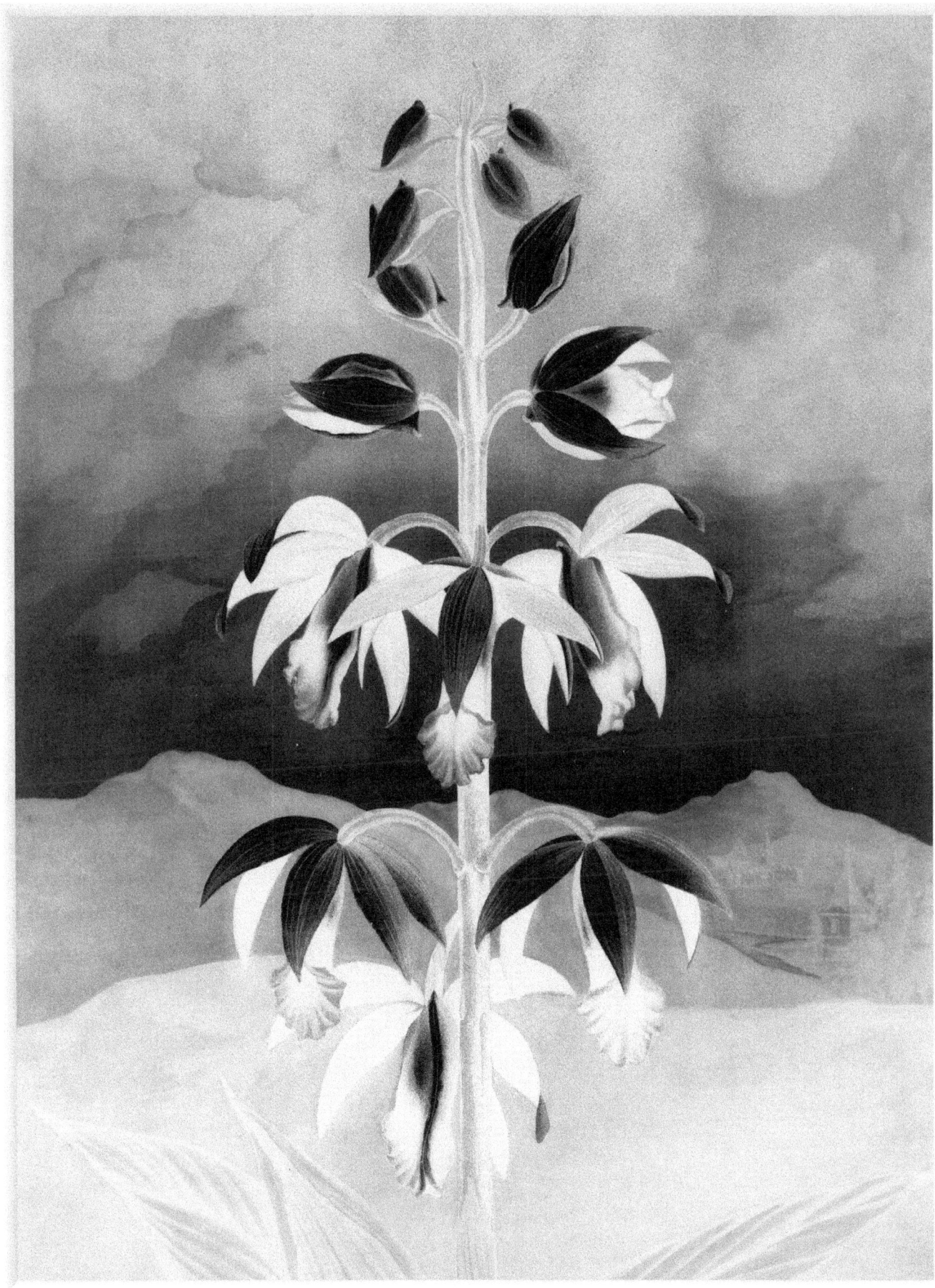

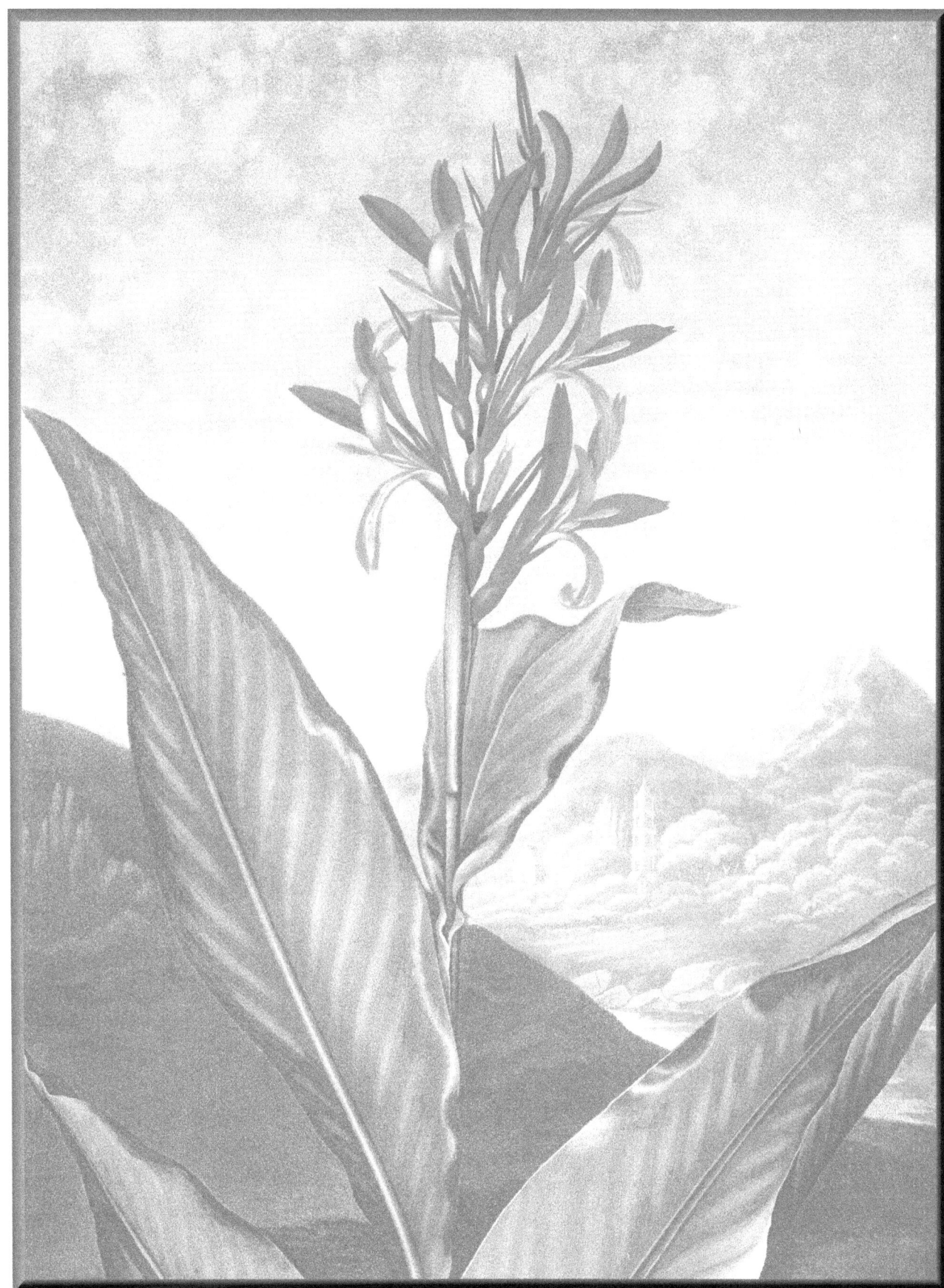

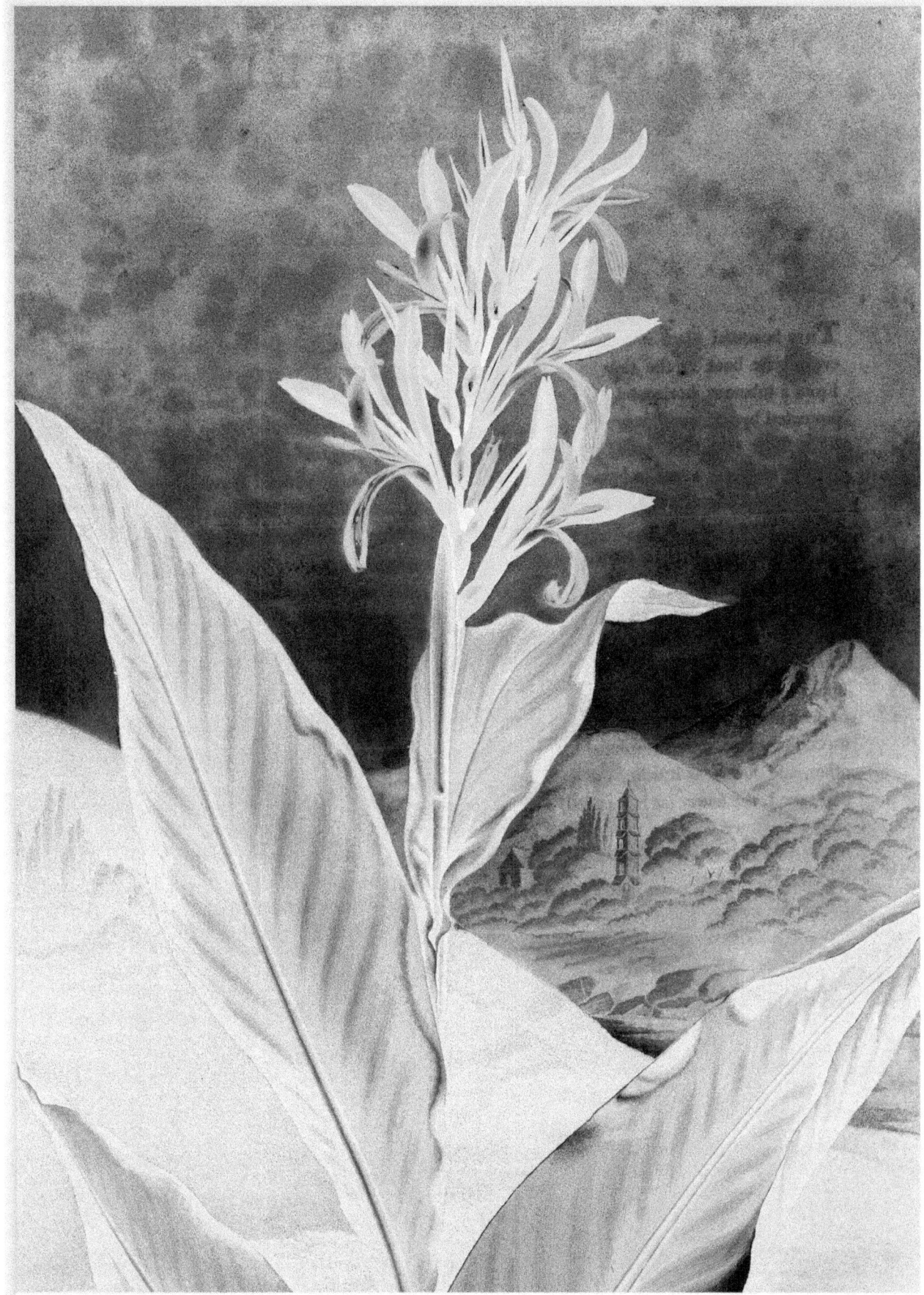

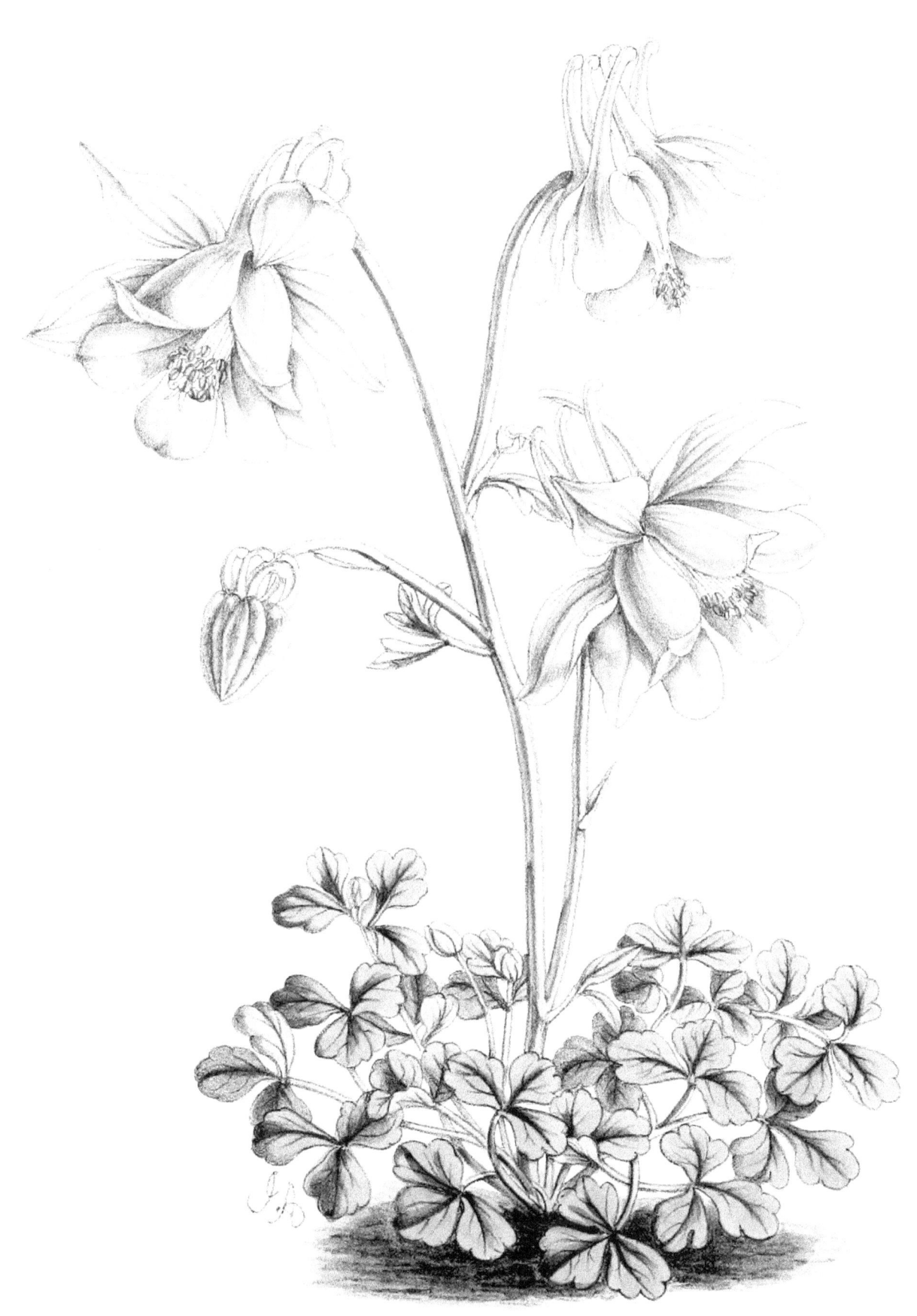

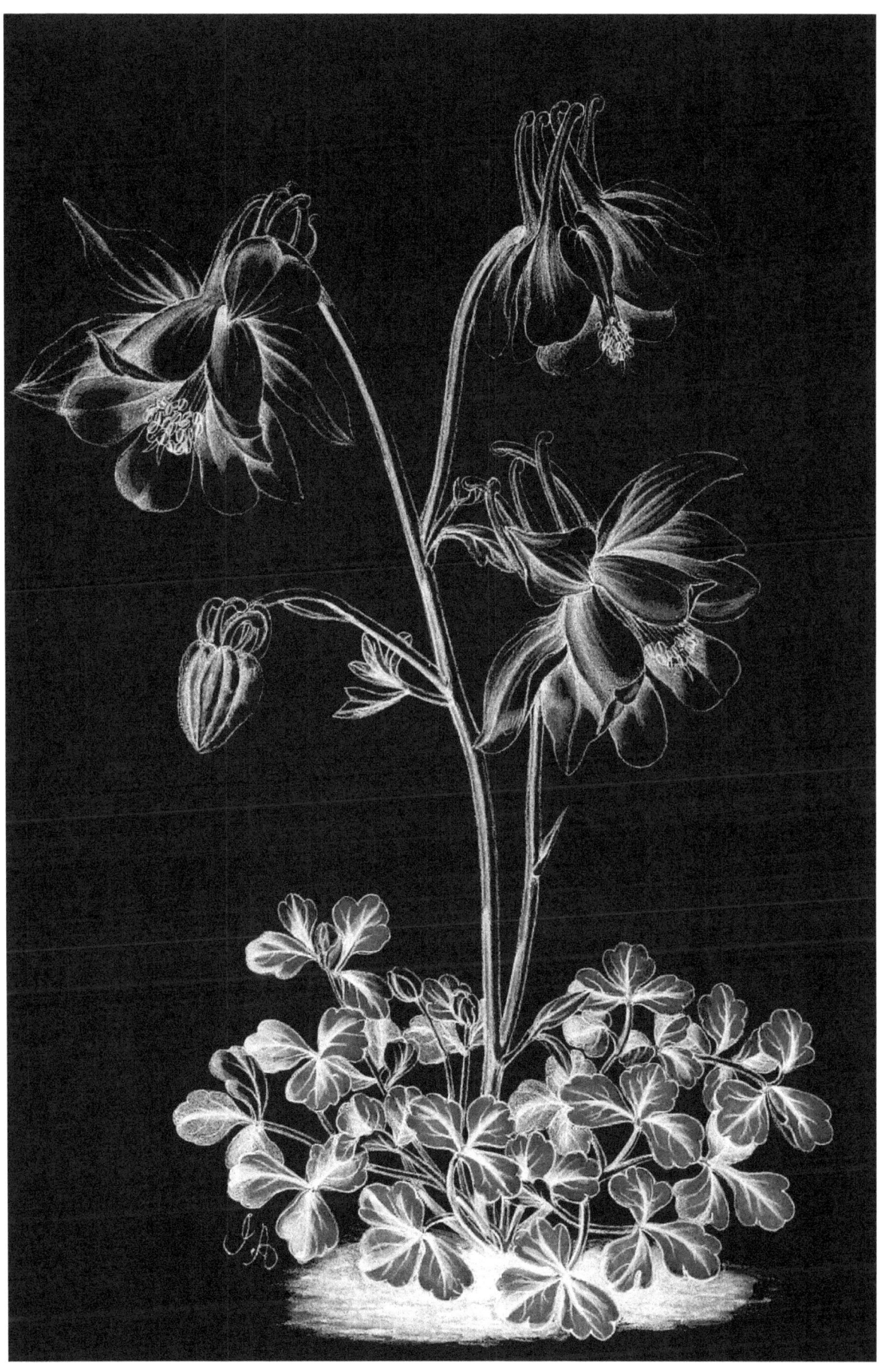

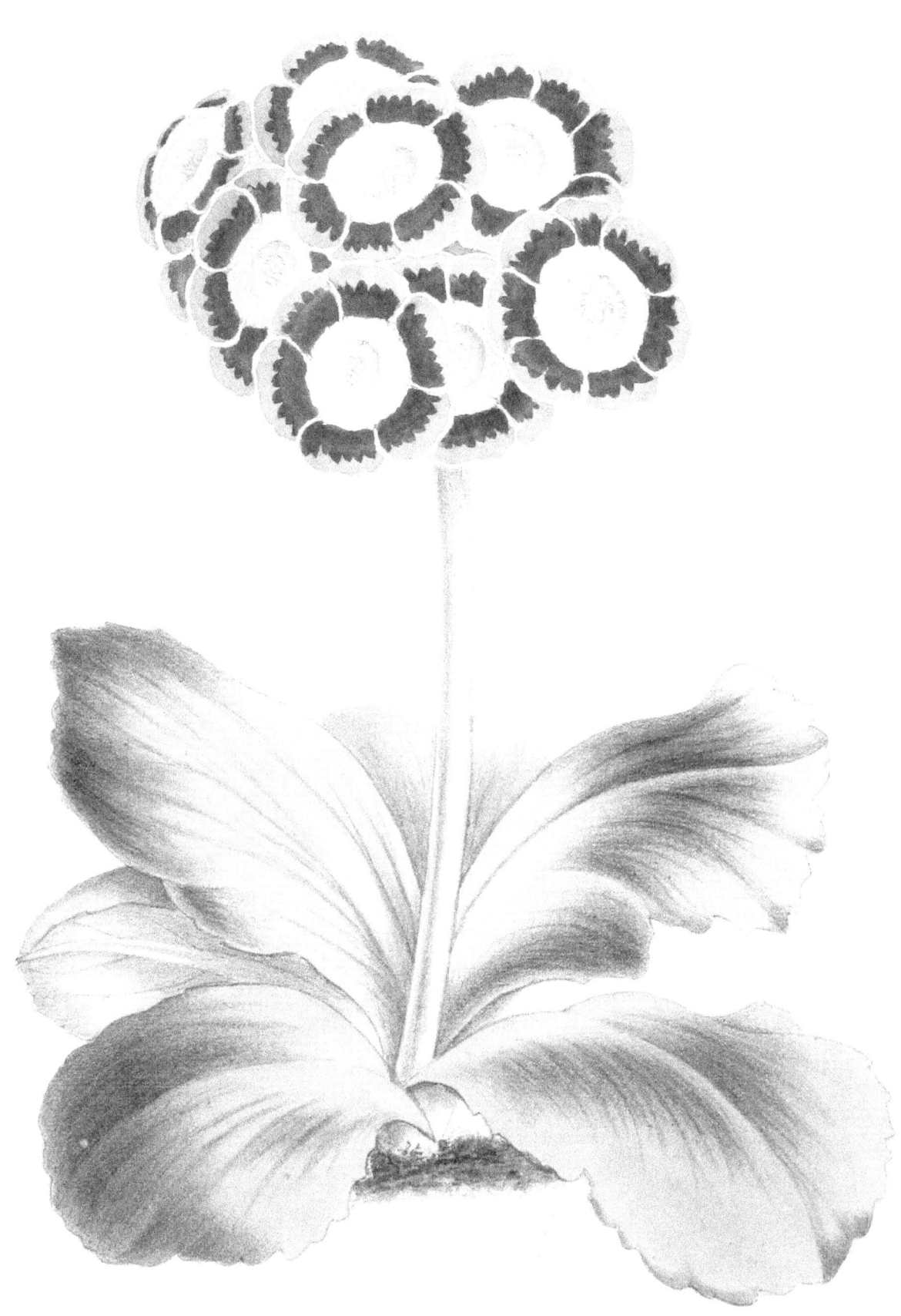

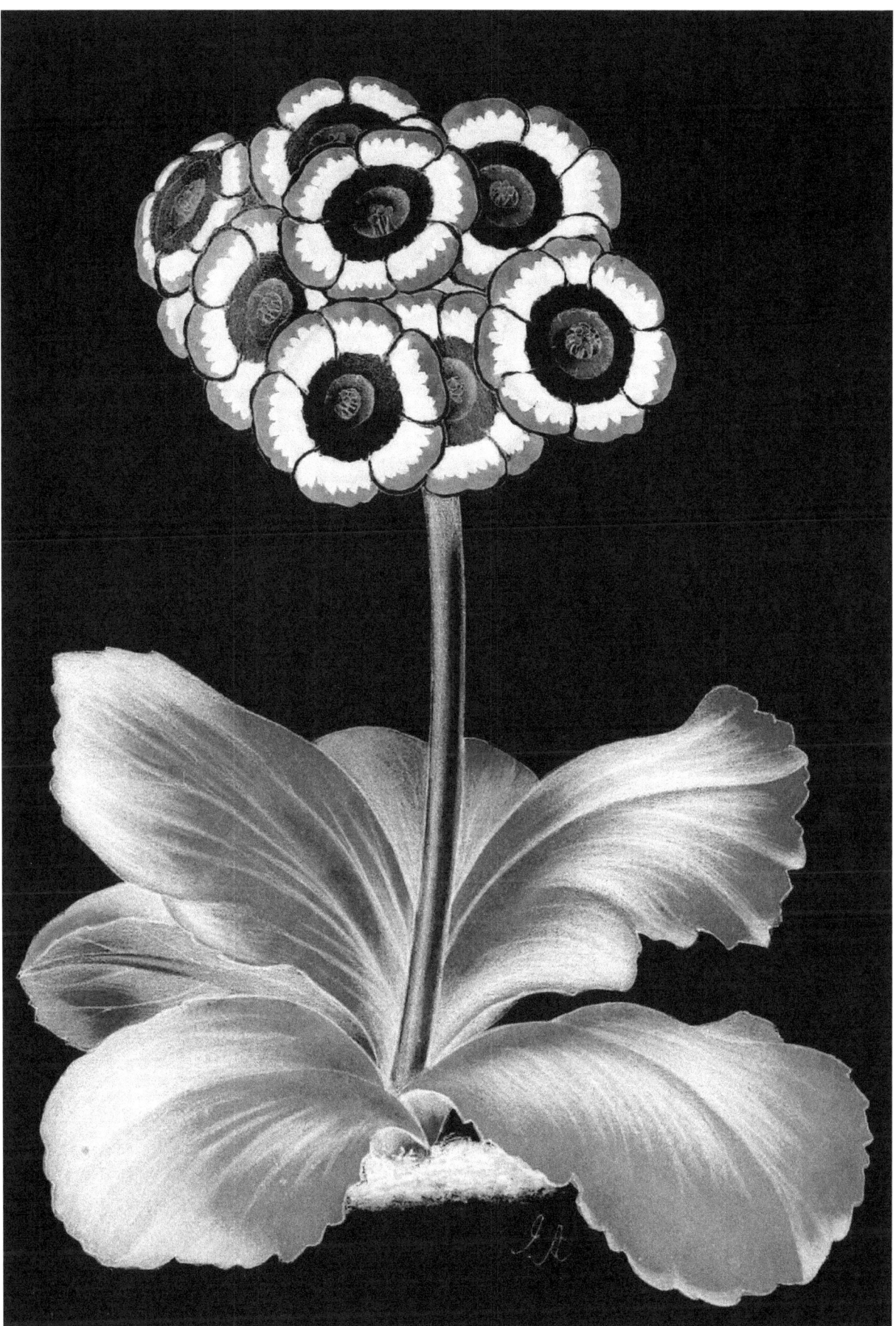

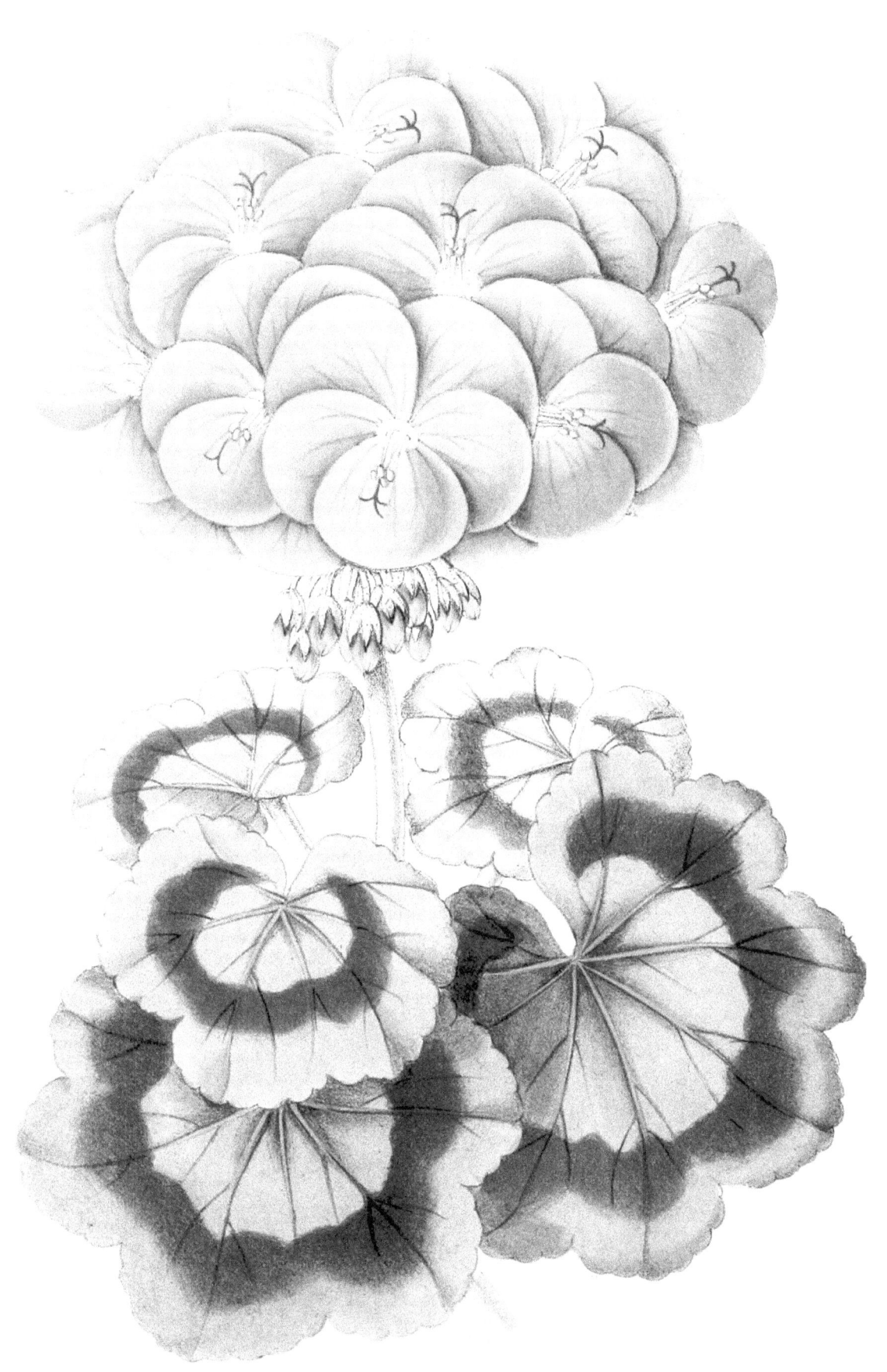

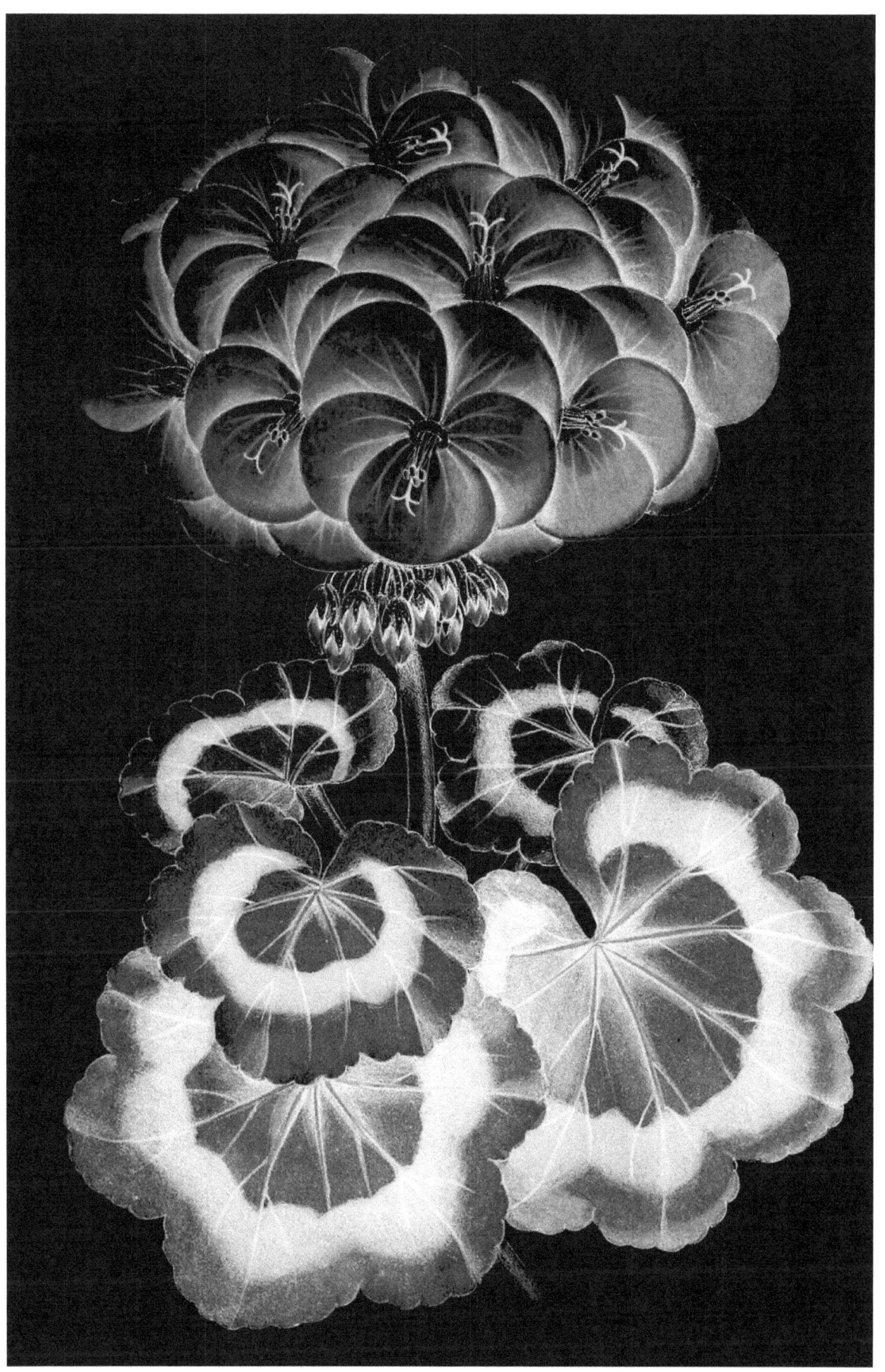

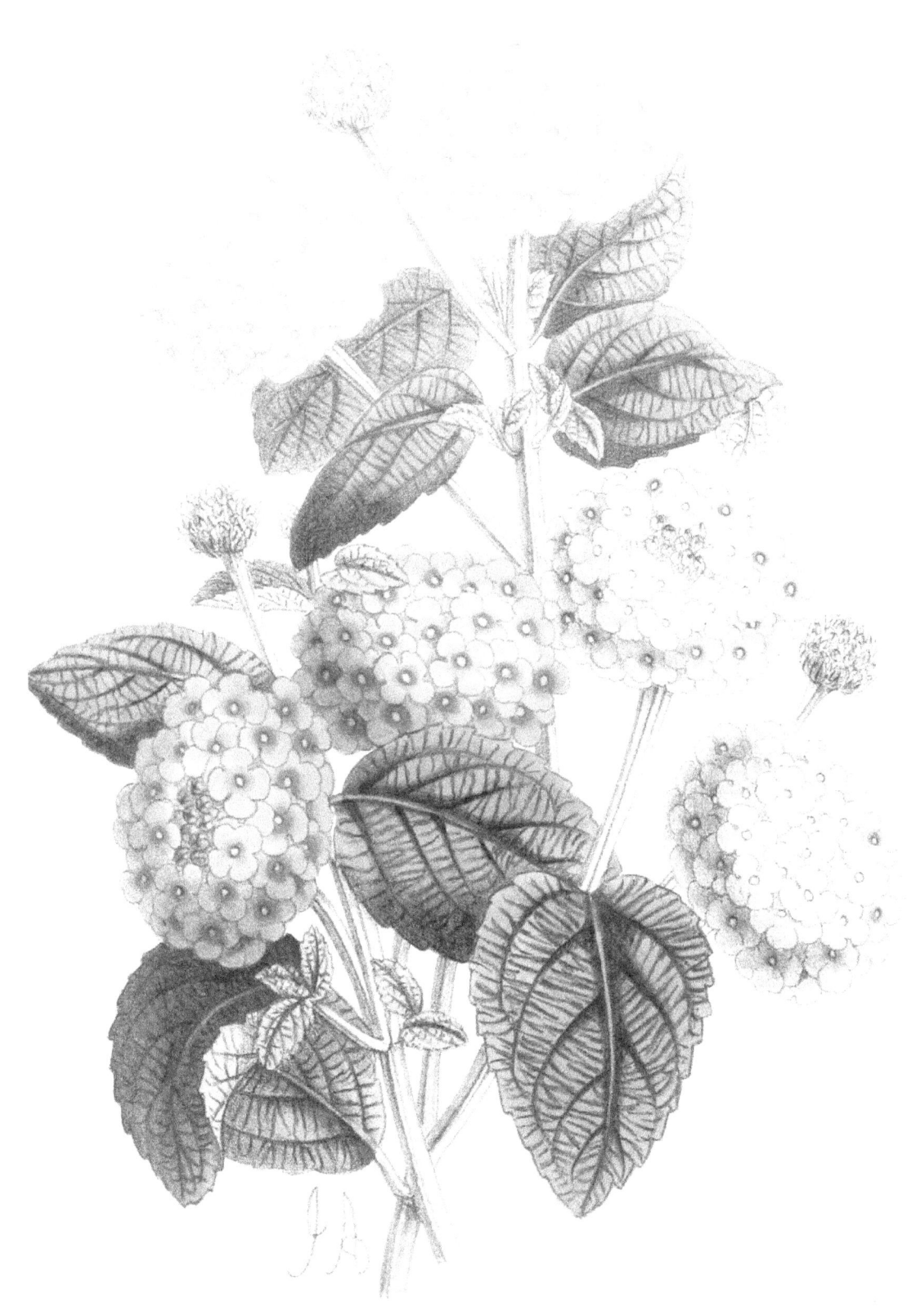

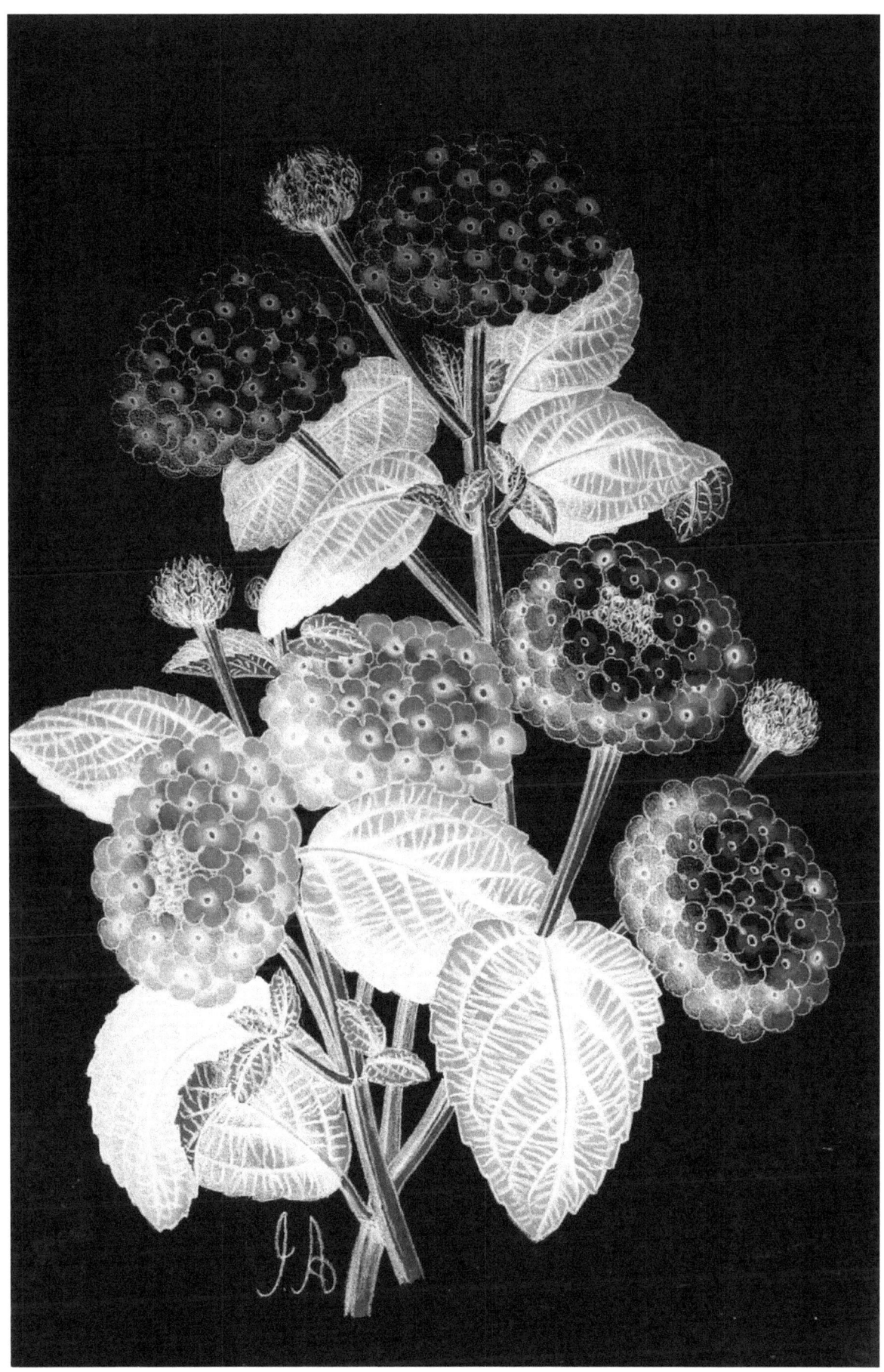

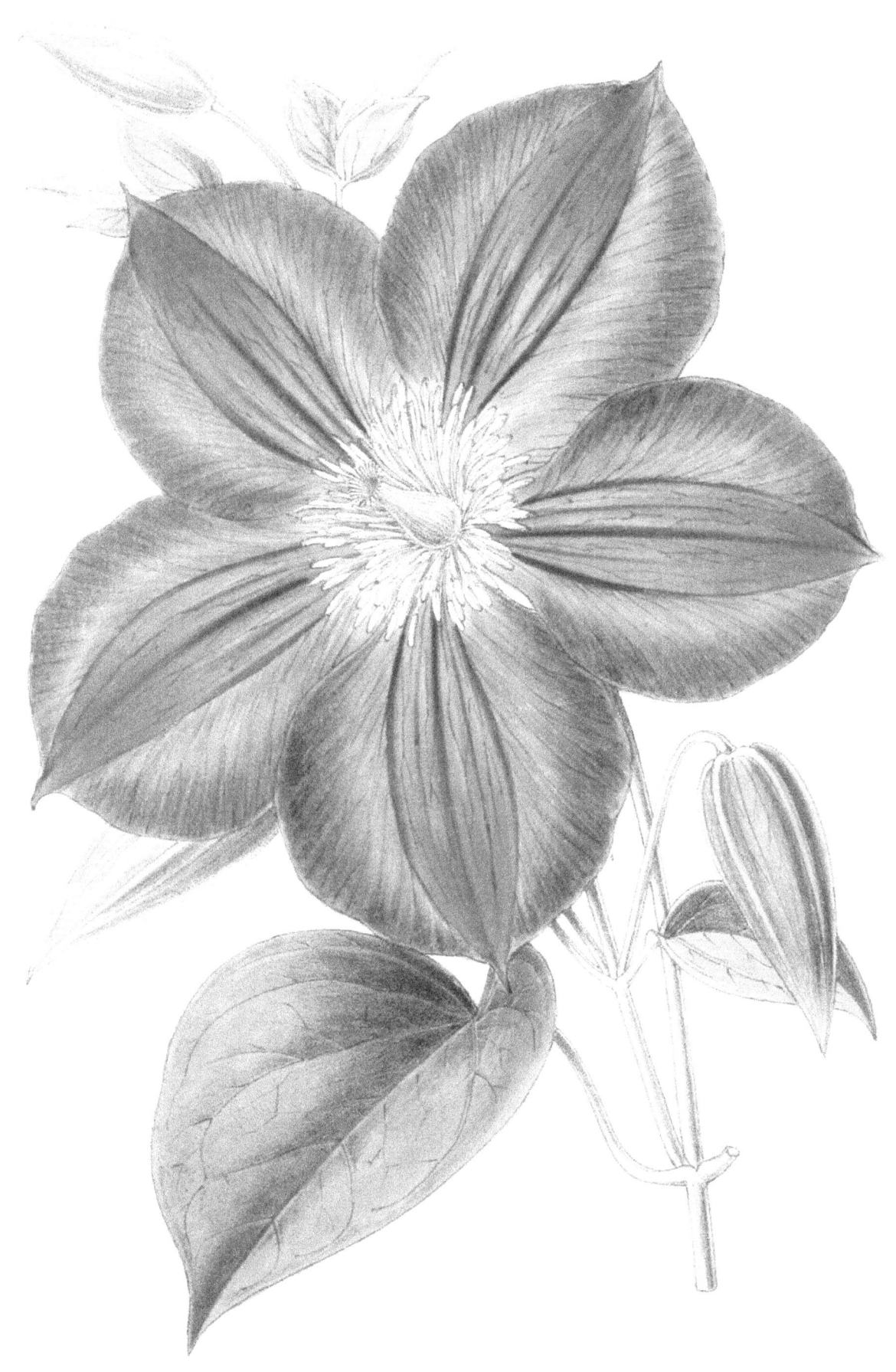

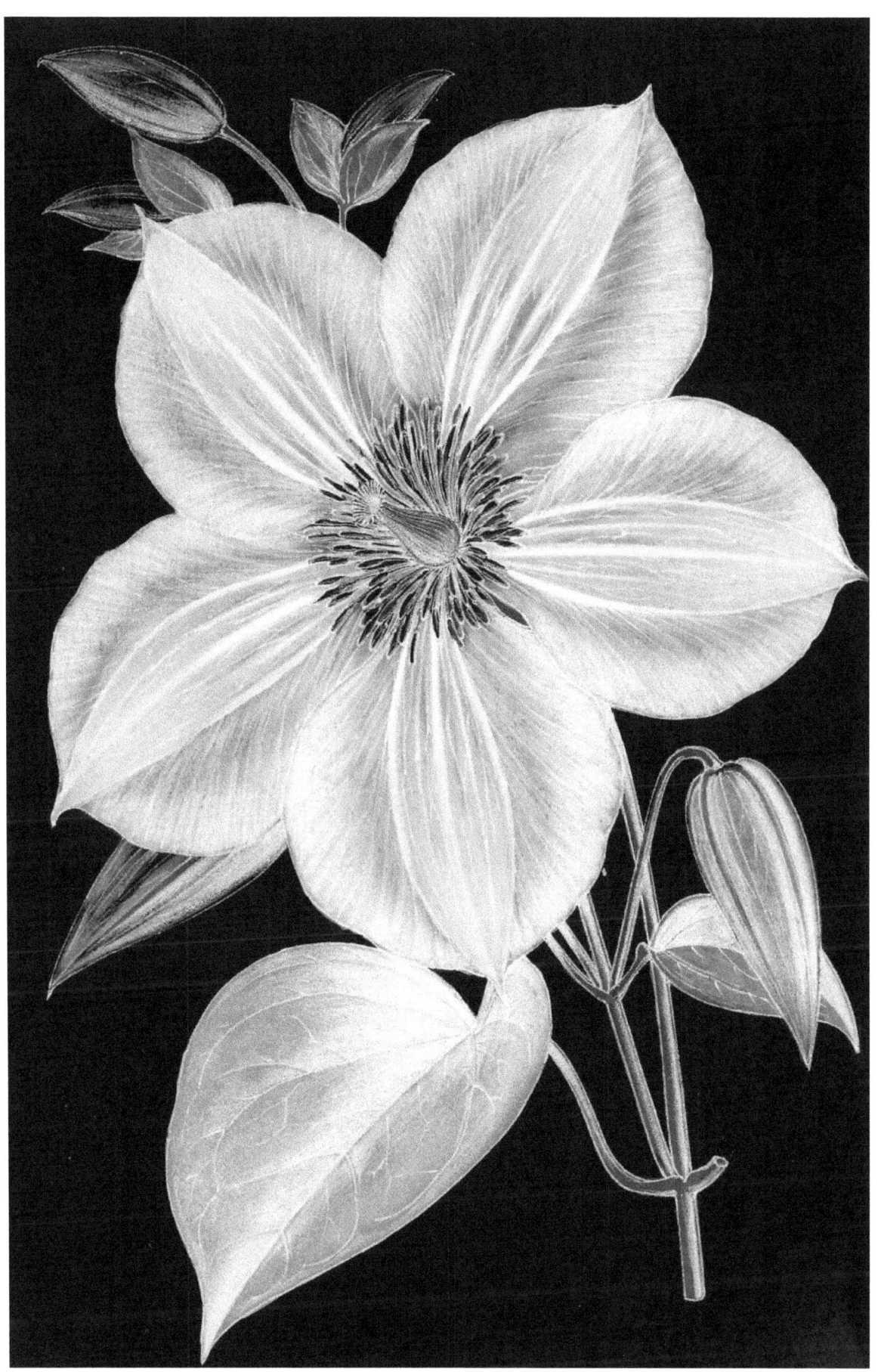

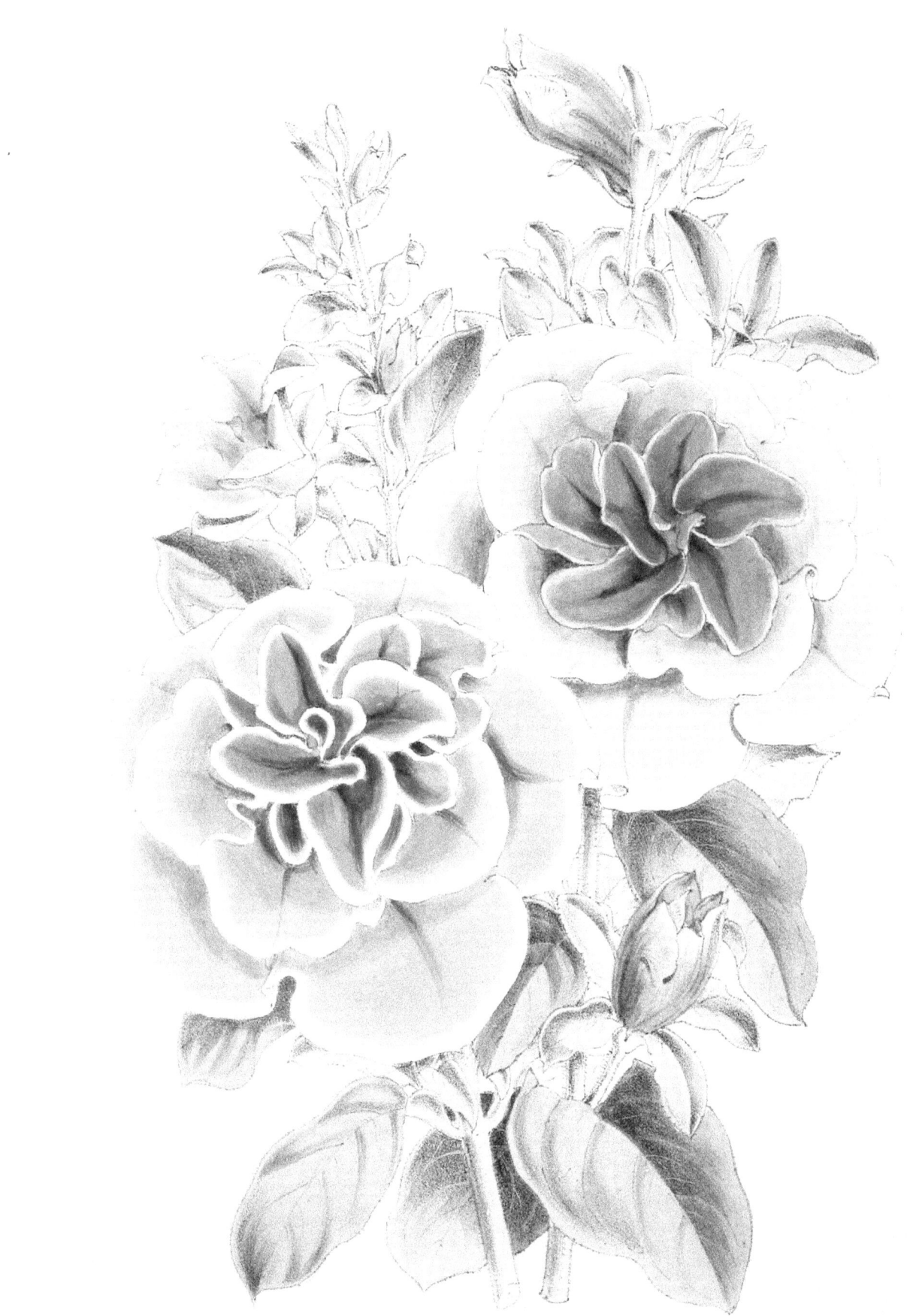

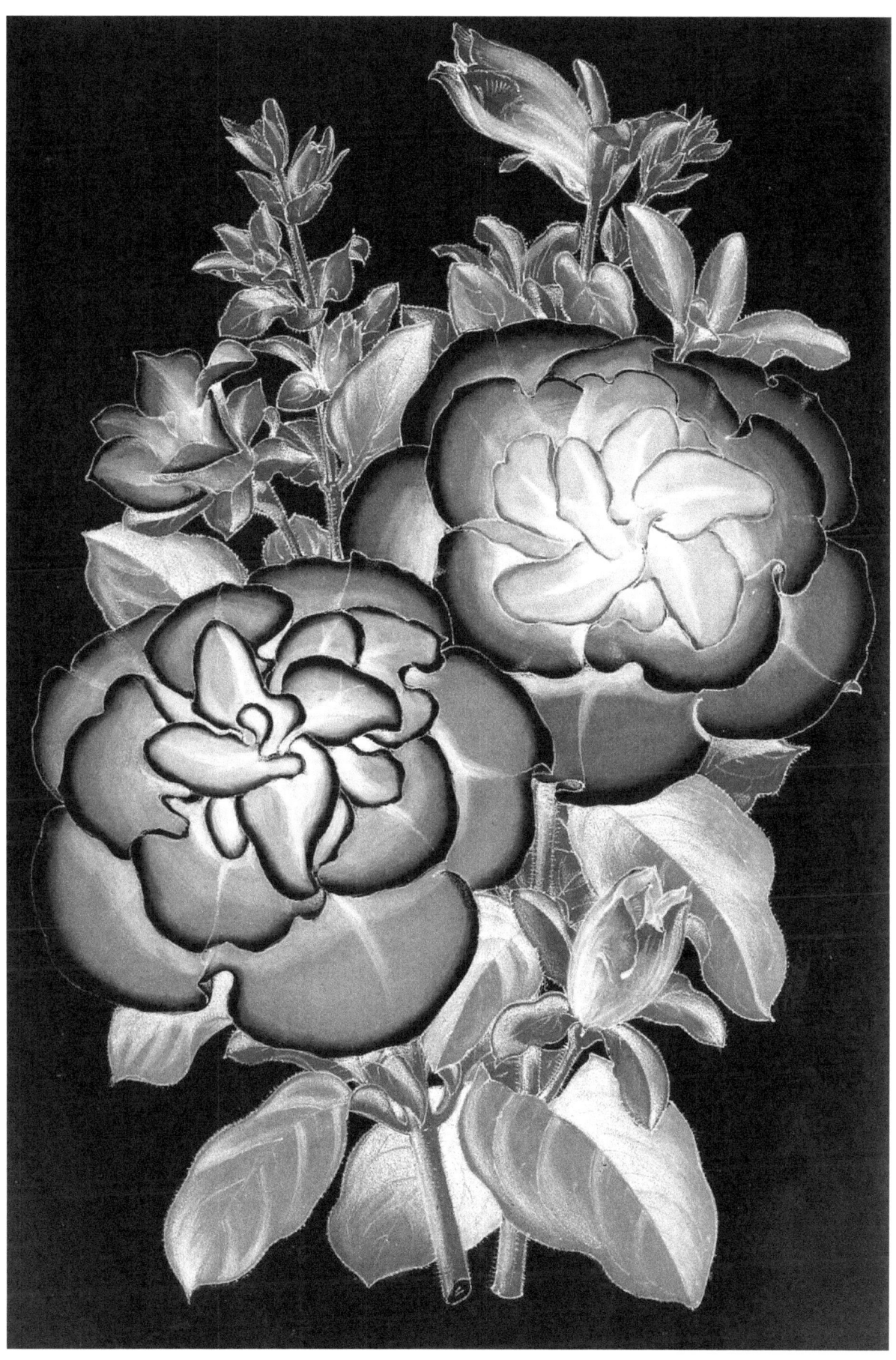

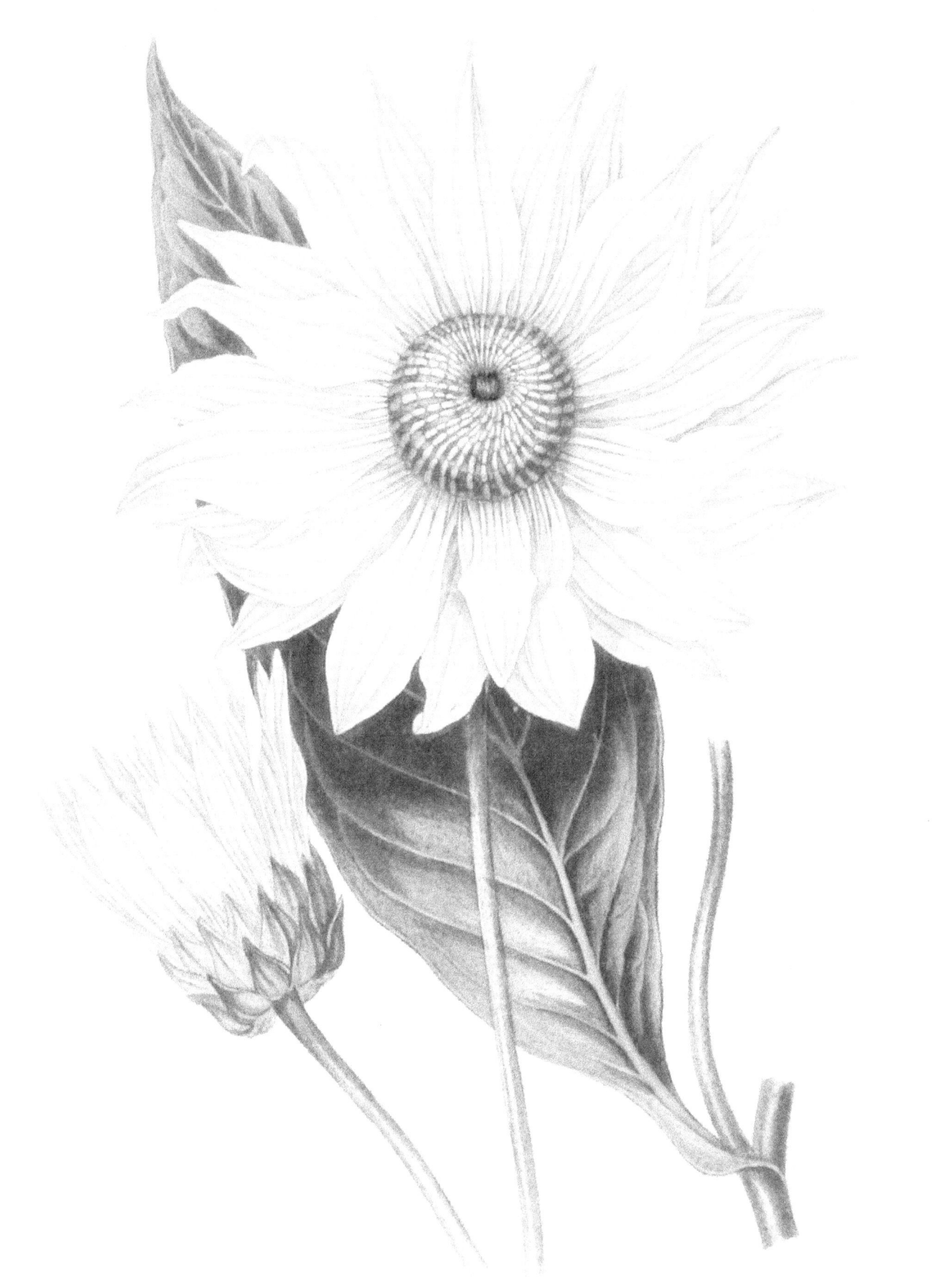

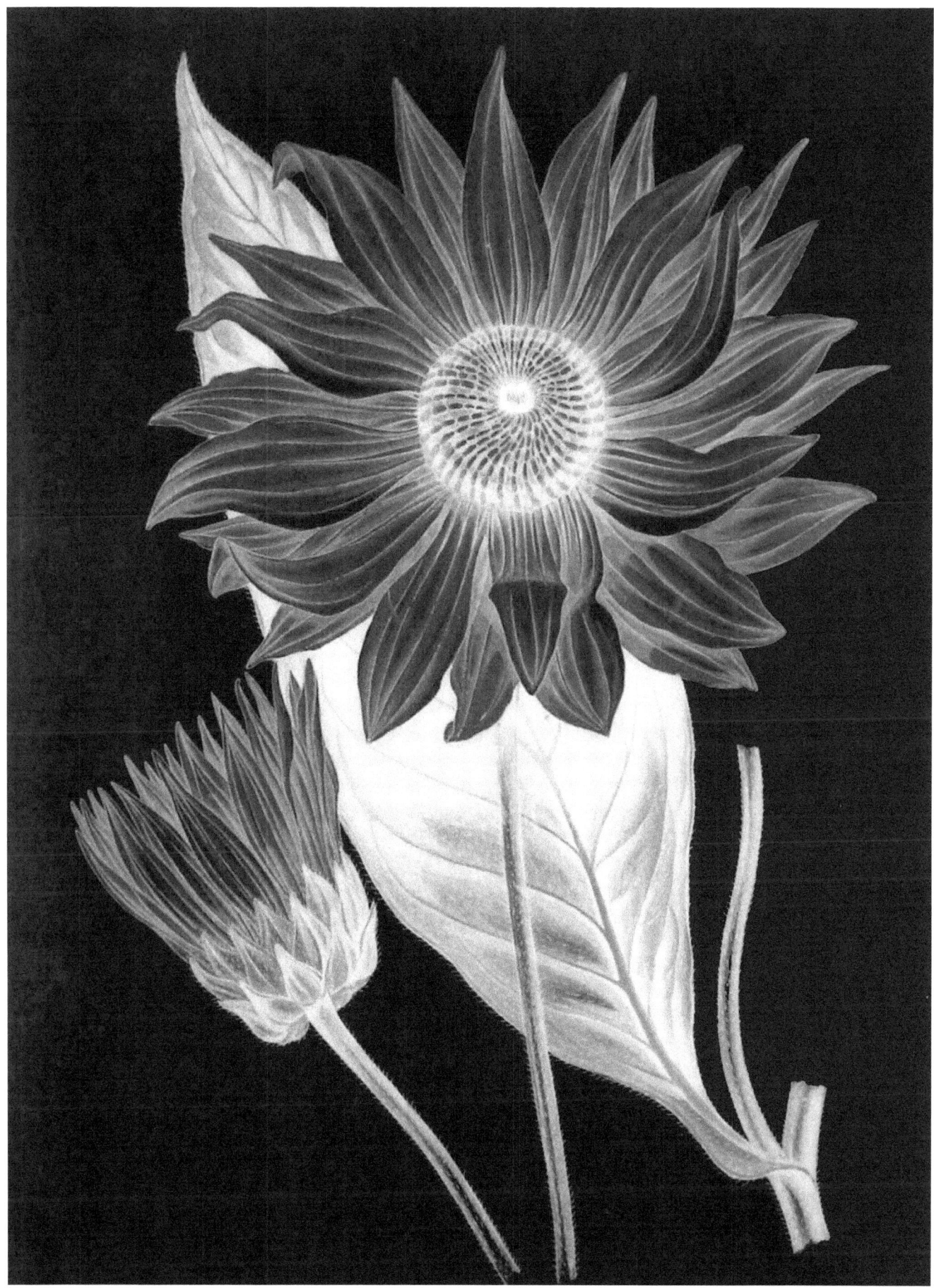

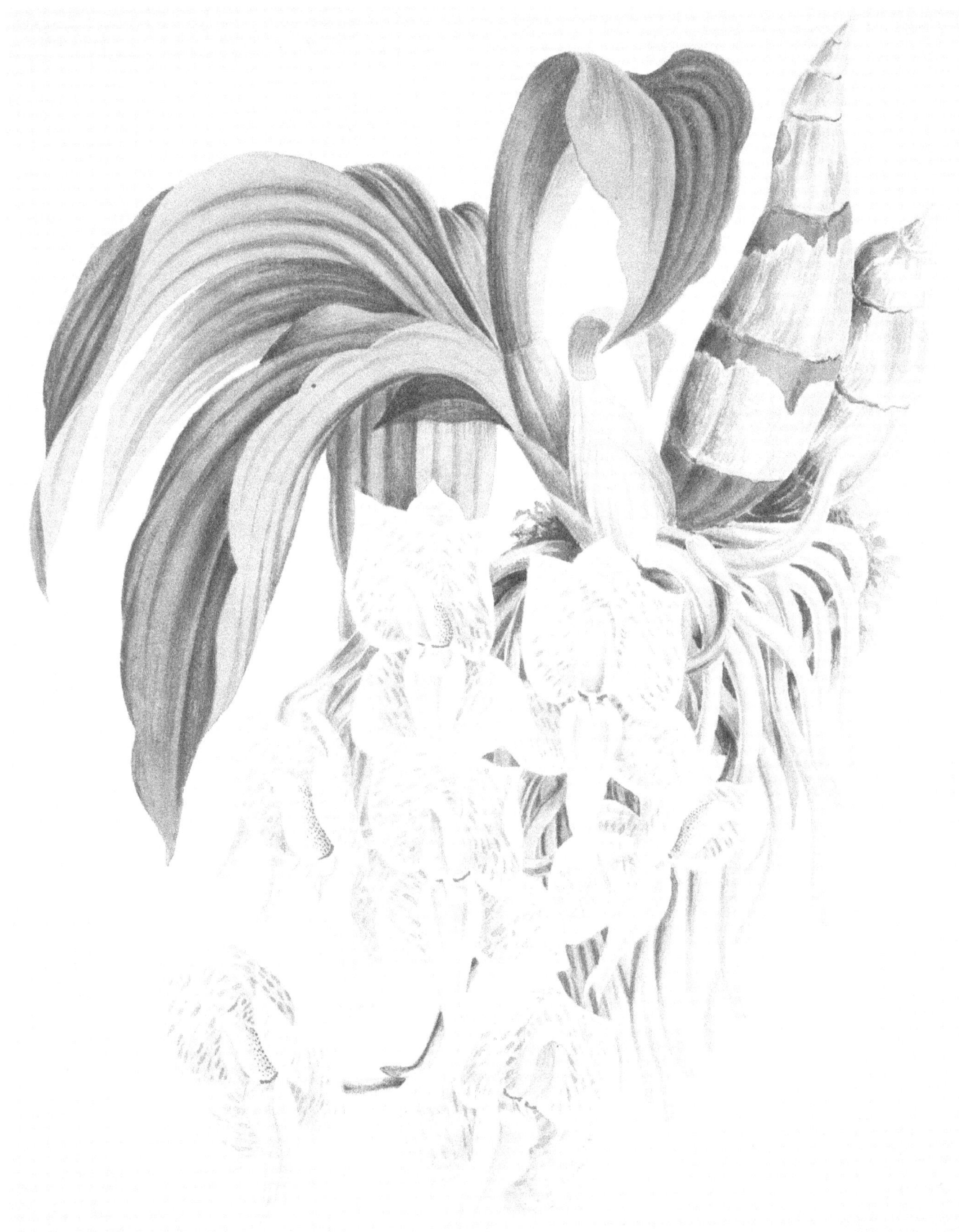

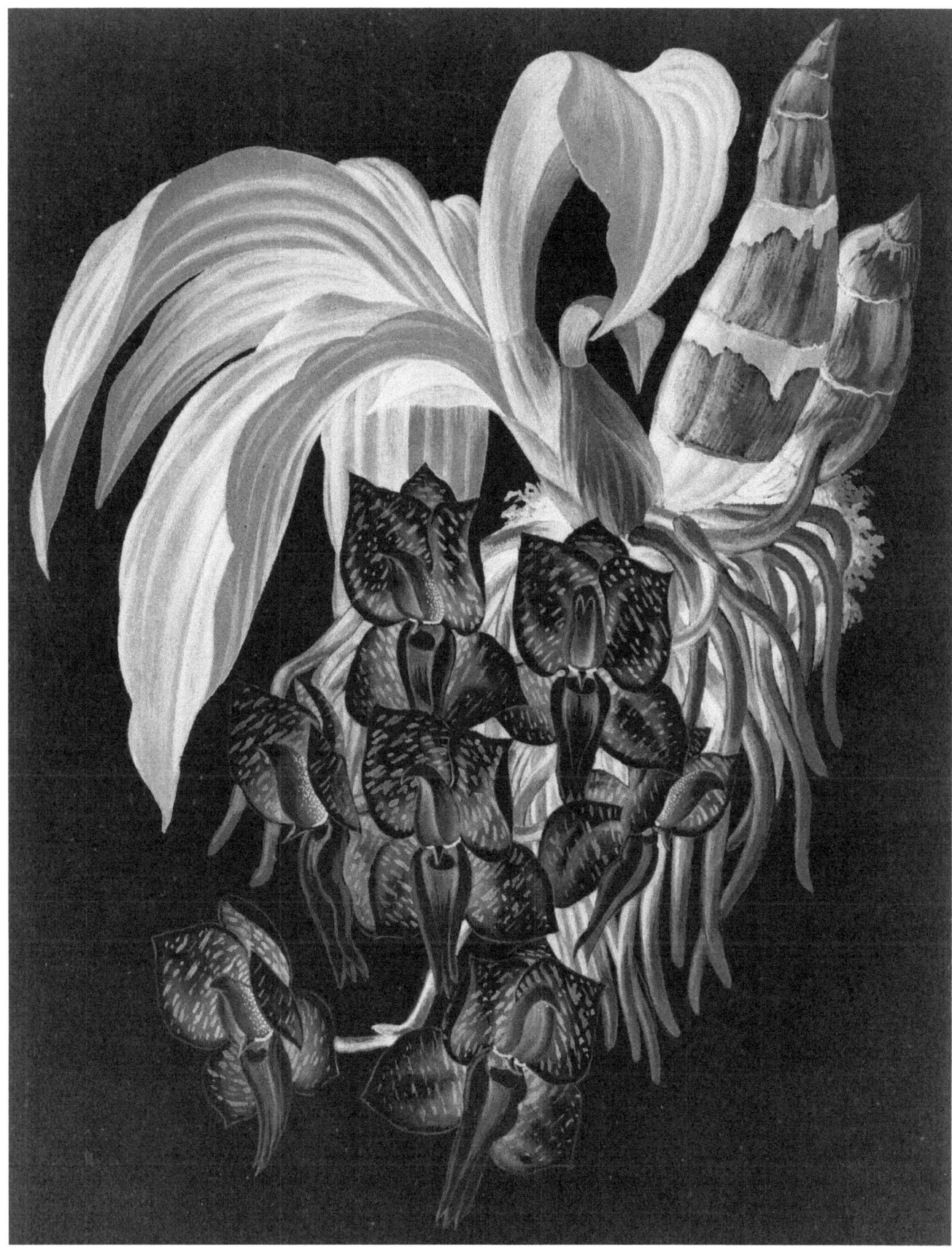

www.ingramcontent.com/pod-product-compliance
Lightning Source LLC
Chambersburg PA
CBHW080712190526
45169CB00006B/2346